C.L C.S F.G

THE ICON and
THE ICONOCLASTS

--

*Celebrating
Monogram*

K.L M.N R.K

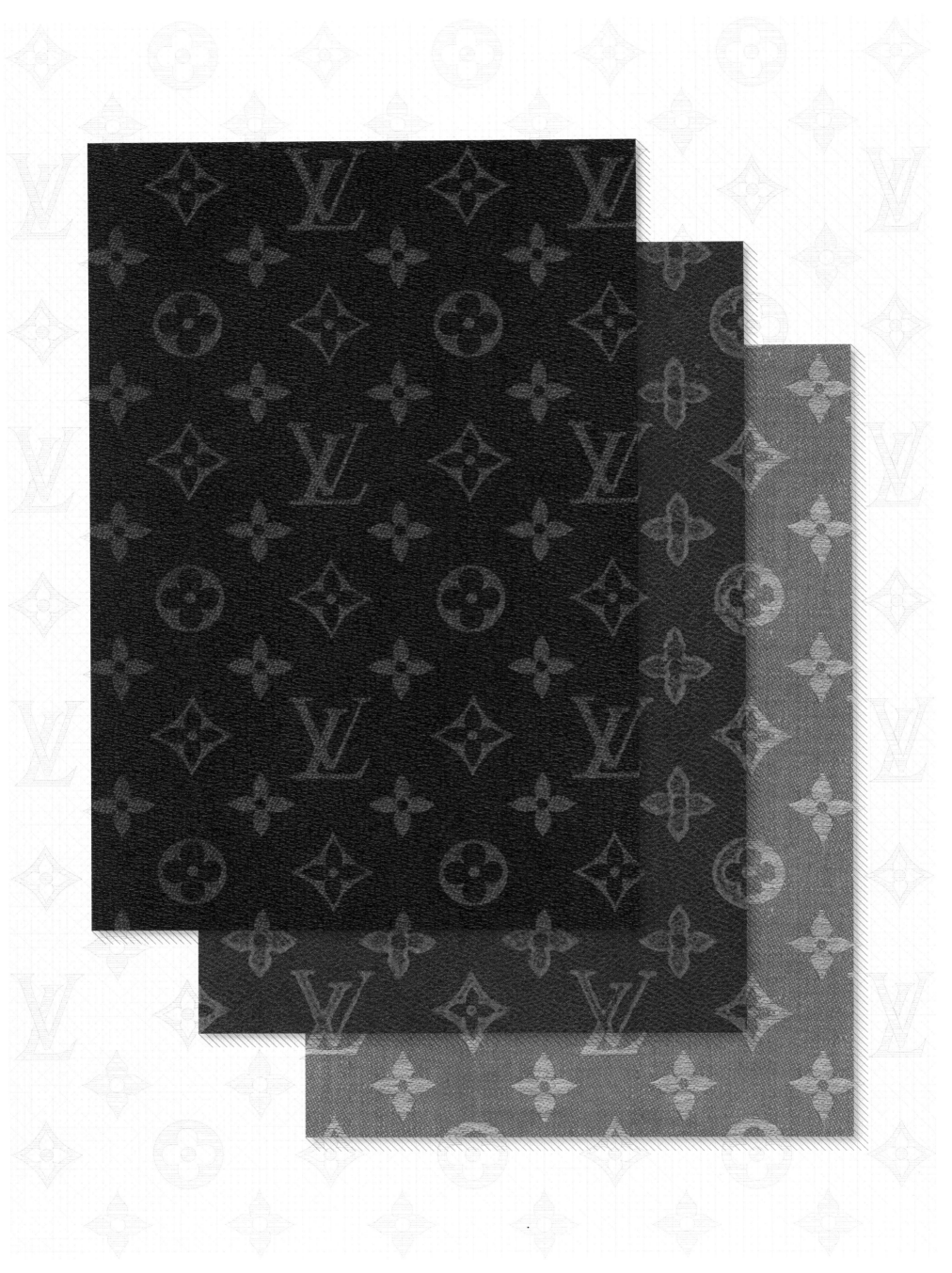

The Monogram canvas since its creation in 1896; from left to right: grained treated, stencilled and woven

WHEN
THE PERSONAL
BECOMES
THE UNIVERSAL:
LOUIS VUITTON's
MONOGRAM

In 1854, LOUIS VUITTON founded his house. In 1896, his son GEORGES VUITTON created the MONOGRAM in honor of his late father. An icon was born.

The MONOGRAM was revolutionary when it appeared. This most particular and personal of signatures was instantly transformed into a universal symbol of modernity in the hands of GEORGES VUITTON.

1896 was a key year for many reasons: it is a time that paves the way for the twentieth century. The creation of the MONOGRAM cannot be divorced from the cultural context in which it first appears. 1896 saw Oscar Wilde's play *Salomé* premiering in French —— while Wilde was in prison —— by Lugné-Poe's Théâtre de l'Œuvre company in Paris. Later in the year —— also in Paris with the same company —— the premiere of Alfred Jarry's absurdist play *Ubu Roi* causes a near-riot. Symbolism is in full swing and the artists later to be labeled "Post-Impressionists" are at work: Gauguin, Cézanne, Lautrec, and Les Nabis are amongst this number. 1896 also happens to be the year that André Breton, Tristan Tzara, and F. Scott Fitzgerald are born.

In short, this is a time when the shock of the new is still shocking. Paris is at the center of provocation, daring, and modern —— both with a small and large M —— and GEORGE VUITTON's LV MONOGRAM is essentially part of this phenomenon.

To paraphrase Cézanne's famous maxim, *"Treat nature by the cylinder, the sphere, the cone…"* The abstract pattern of the MONOGRAM, could be seen to treat nature by the diamond, circle, and the letter. Its ingenious abstraction is one of the reasons why the MONOGRAM has maintained its effortlessly modern appearance, through generations and across time.

In 1965, GASTON-LOUIS VUITTON, recounted how his father, GEORGES, had created the motifs of the MONOGRAM canvas: *"First of all, the initials of the company —— LV —— are interlaced in such a way as to remain perfectly legible. Then a diamond. To give a specific character to the shape, he made the sides concave with a four-petal flower in the center. Then the extension of this flower in a positive image. Finally, a circle containing a flower with four rounded petals."* It should also be noted that before achieving success and renown, the MONOGRAM met with some resistance.

GASTON-LOUIS VUITTON explained that *"the public was initially reticent and demanded the chequered and even striped canvas, but my father stood firm."*

The MONOGRAM pattern is composed of stylised flowers, shapes, and letters organized geometrically; yet there is still some debate as to whether the radical graphic design owes a debt to the neo-Gothic style, the influence of Japonisme or the symbolic, graphic art of Les Nabis. Alternatively, and more prosaically, the tiles in the VUITTON family home might have inspired the pattern. Nevertheless, one thing is for sure, the MONOGRAM is now recognized globally as a defining signature, both literally and metaphorically, of the house of LOUIS VUITTON.

What was initially an audacious gamble on the part of GEORGES VUITTON, a man who dared to sign leather goods and travel objects like an artist (Toulouse Lautrec's signature holds certain parallels) and was more than *au fait* with the contemporary cultural milieu, instantly and iconoclastically, elevated the meaning of the craft of LOUIS VUITTON in one fell swoop, through the MONOGRAM.

As the MONOGRAM has traveled through time, certain of its features and meanings remain the same. Blurring the boundaries between craftsmanship, art and design, LOUIS VUITTON has repeatedly embraced the notions of innovation, collaboration and daring throughout the MONOGRAM's history. From the famous, hardwearing, all-weather canvas that was originally utilized for trunks, to its supple incarnation for bags, in recent years the MONOGRAM has gone on to embrace all manner of materials including a whole host of leathers and even denim. Yet one thing has varied very little: the graphic design of the pattern itself.

Yet there is always an exception to every rule, and this occurred in 2001 with VUITTON's truly iconoclastic collaboration with STEPHEN SPROUSE. The MONOGRAM Graffiti shows the act of creation through destruction like nothing else in LOUIS VUITTON's history, with a simultaneous subversion and adoration of the MONOGRAM. In fact, so successful was the collaboration, quickly moving from the iconoclastic to the iconic, in 2009 a MONOGRAM Graffiti tribute collection was made available.

In 2003, the MONOGRAM Multicolore collaboration with the artist TAKASHI MURAKAMI became another, iconic global hit. Redefining what people thought of the MONOGRAM once more, his MONOGRAM Cerises (2005) and MONOGRAMouflage (2008) followed. Through MURAKAMI, *"playful"* as well as daring has been an epithet attributed to the MONOGRAM, and perhaps reaches its peak with RICHARD PRINCE's bags for the Spring-Summer 2008 fashion show, which are often emblazoned with his Joke pieces.

It is within this context that LOUIS VUITTON's <u>THE ICON and THE ICONOCLASTS:</u> *Celebrating Monogram* project appears this year. It is a series of works that shows the distinctly personal side of the MONOGRAM; re-presenting something we think we all know in an extraordinary, individual, and idiosyncratic way.

Six creative iconoclasts, the best in their fields, who blur the lines between fashion, art, architecture and product design, have been given carte blanche to dictate and make whatever they see fit in the iconic canvas.

CHRISTIAN LOUBOUTIN, CINDY SHERMAN, FRANK GEHRY, KARL LAGERFELD, MARC NEWSON, and REI KAWAKUBO radically, personally, and playfully realize an unparalleled collection.

In many ways, it means the MONOGRAM has come full circle. Looking at its handcrafted roots once more, its direct connection to a person, its daring and genre defying audacity and, above all, its journey into the future for LOUIS VUITTON. This is a collection that is both universal and personal, and in the cherished traditions of the house, once again defies expectations.

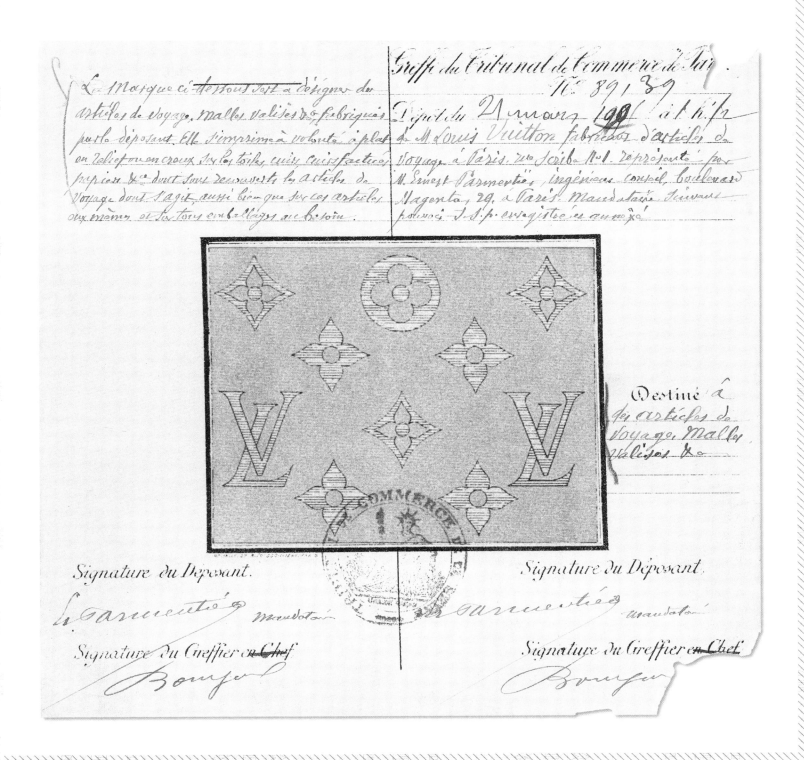

Certificate showing the registration of the Monogram canvas as a trademark at the French National Office for Industrial Property, 1905

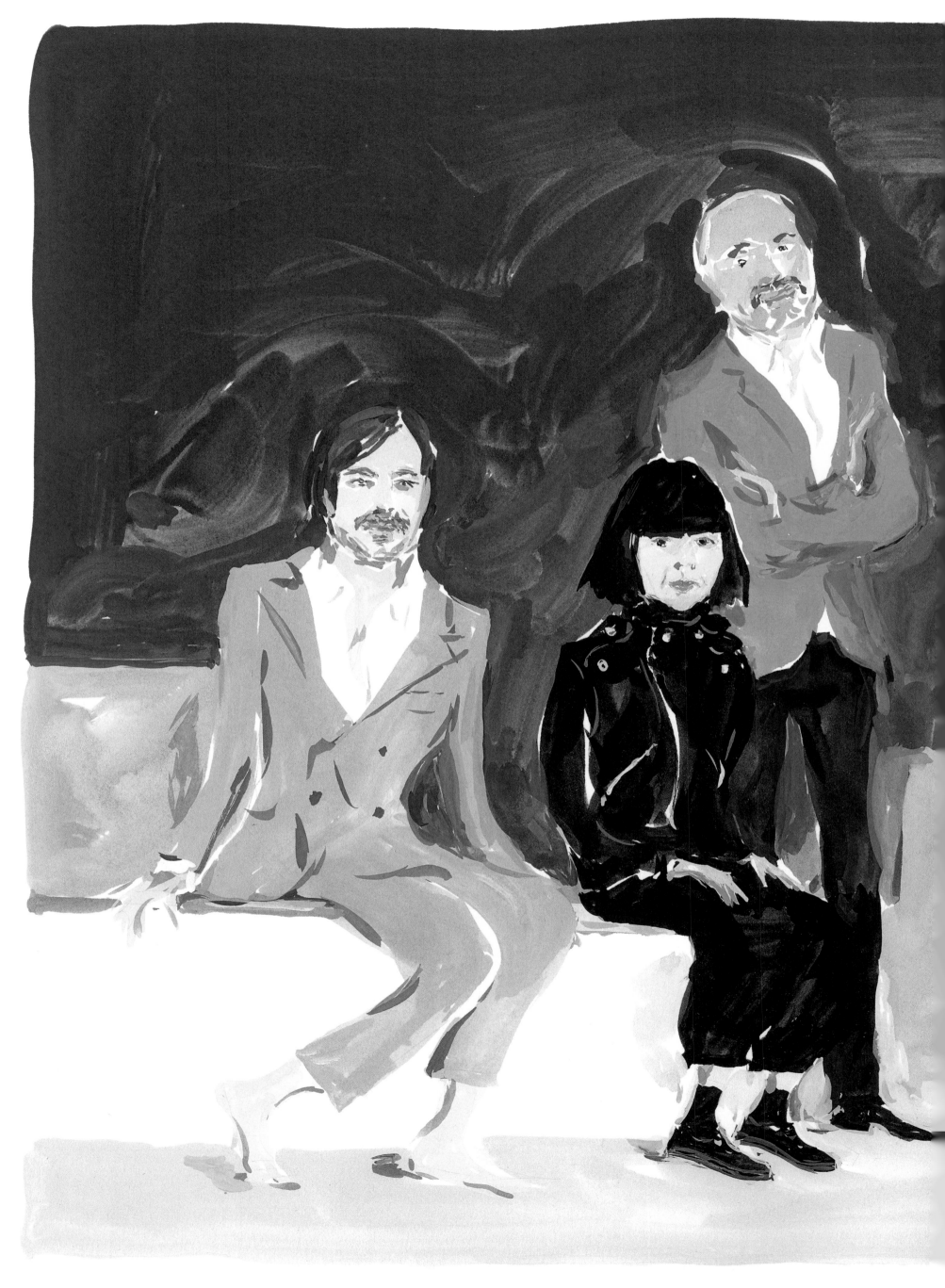

The Iconoclasts: Marc Newson, Rei Kawakubo, Christian Louboutin, Cindy Sherman, Karl Lagerfeld and Frank Gehry. Gouache on paper by Jean-Philippe Delhomme

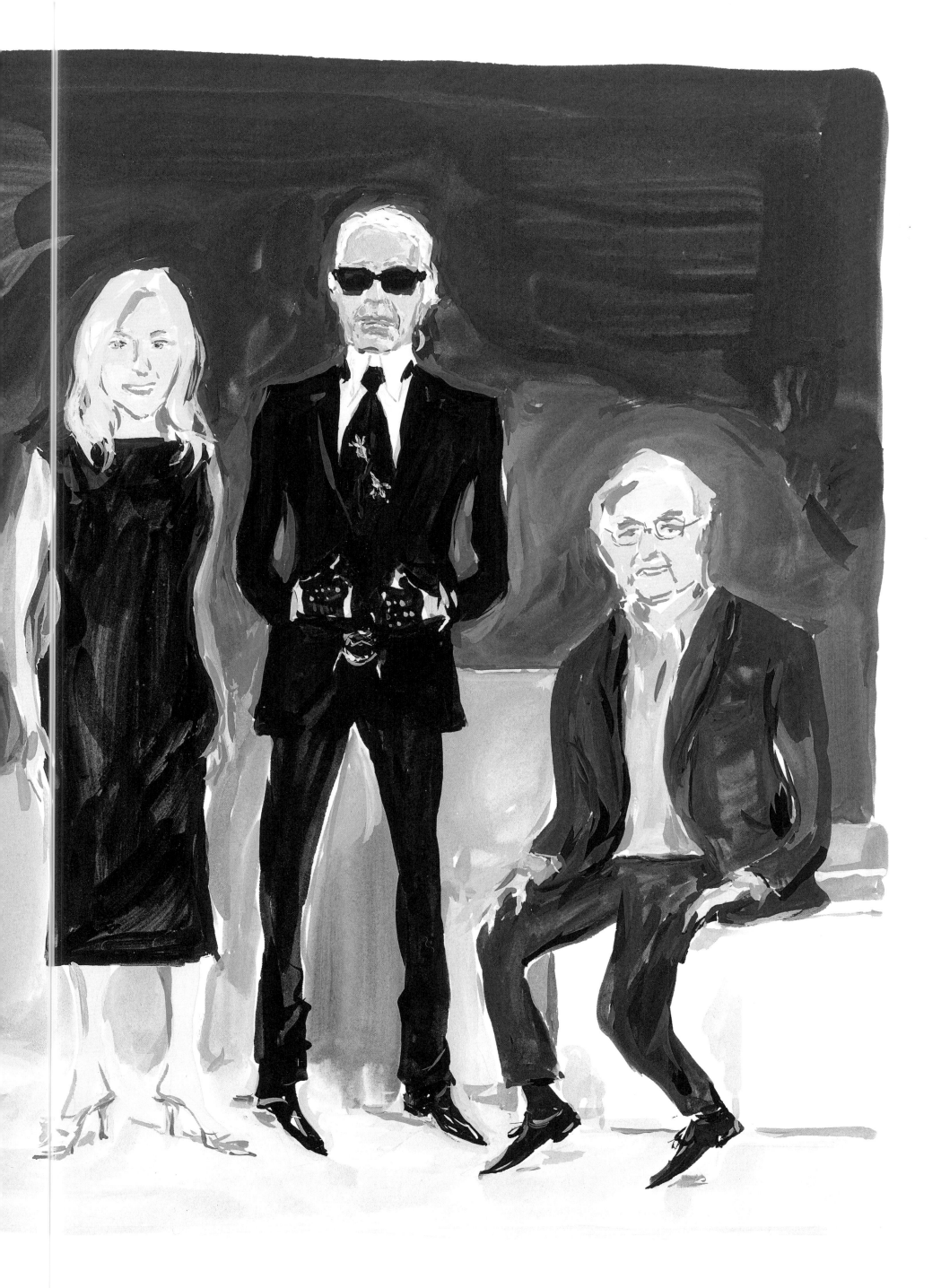

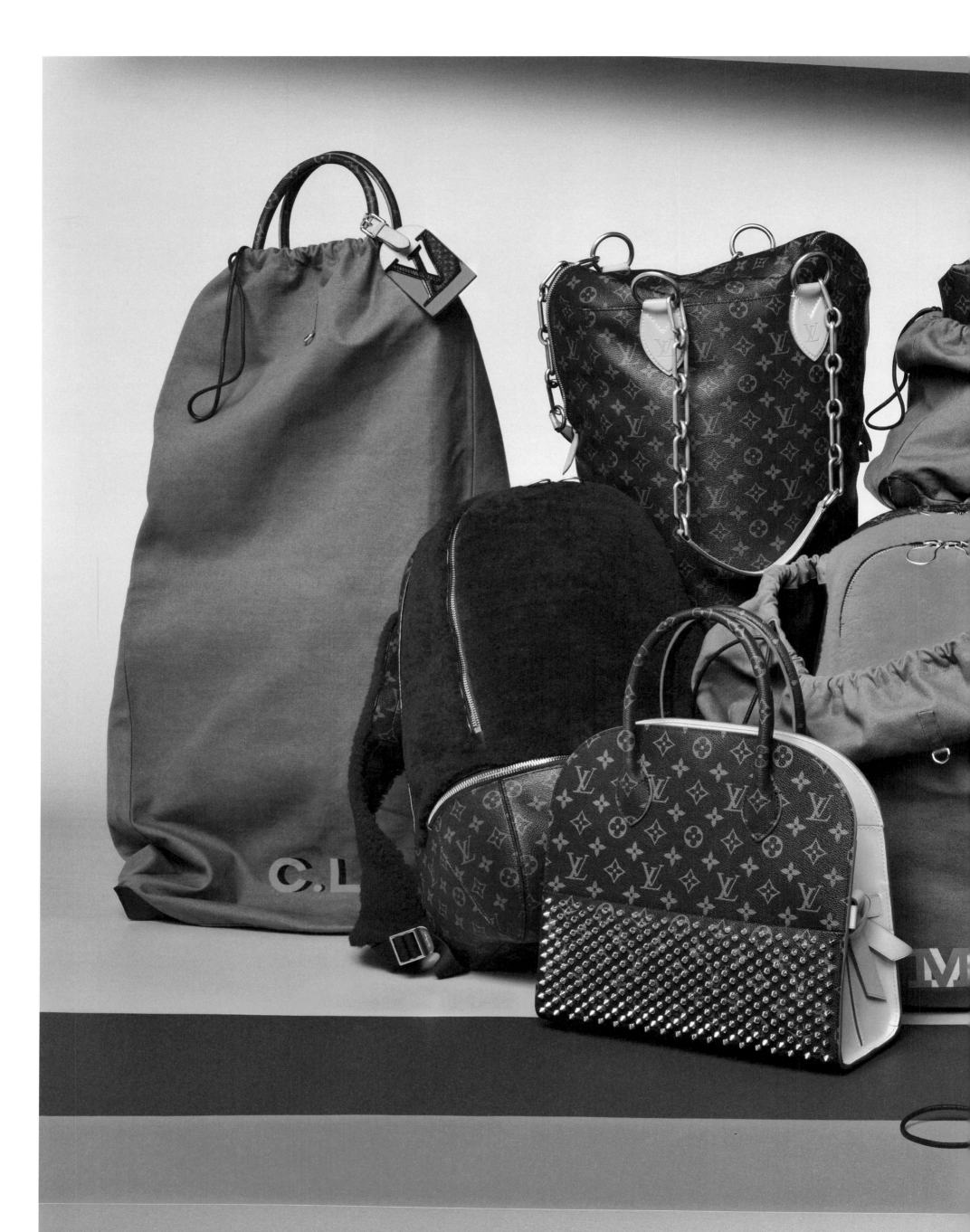

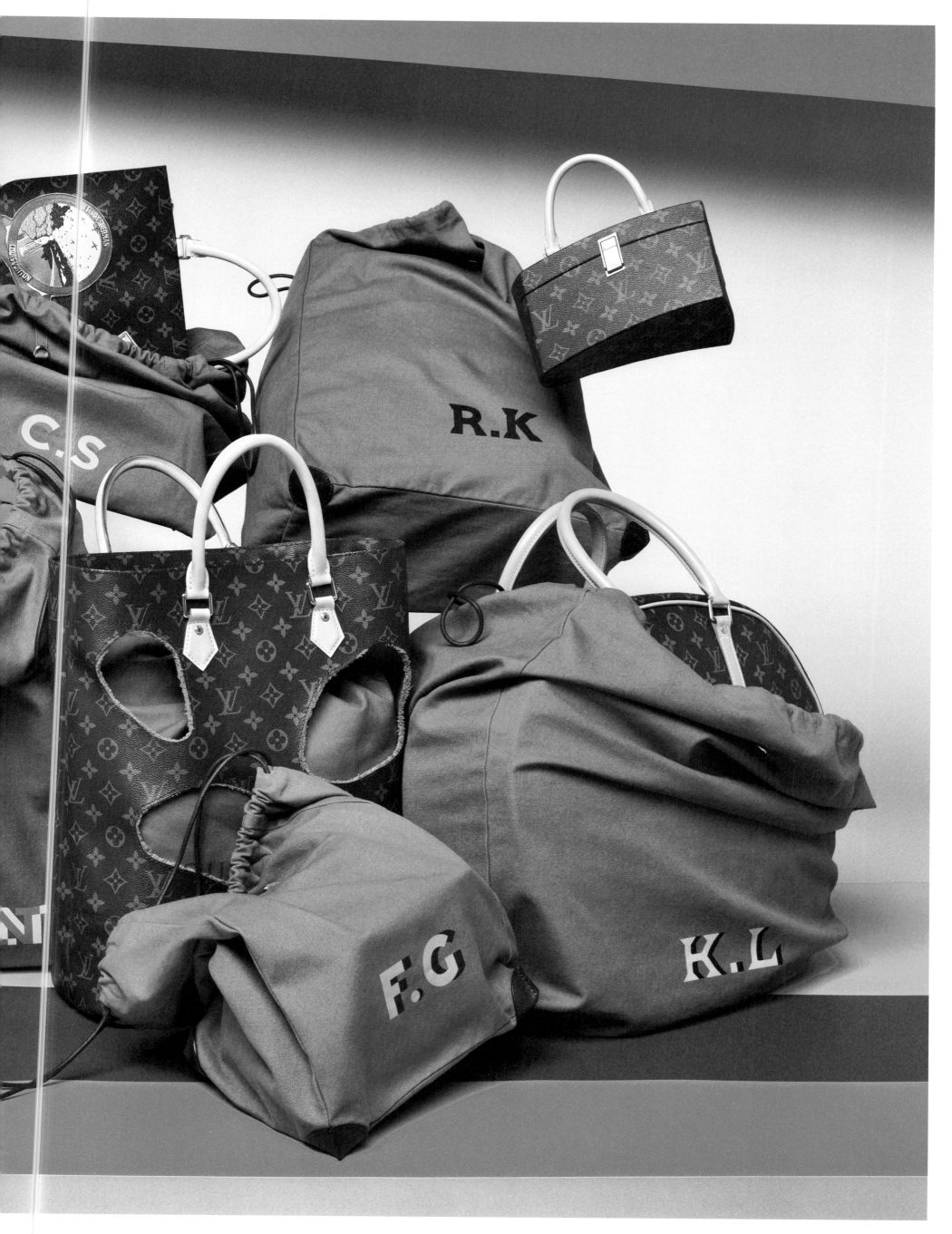

The Iconoclasts' creations photographed by Erwan Frotin

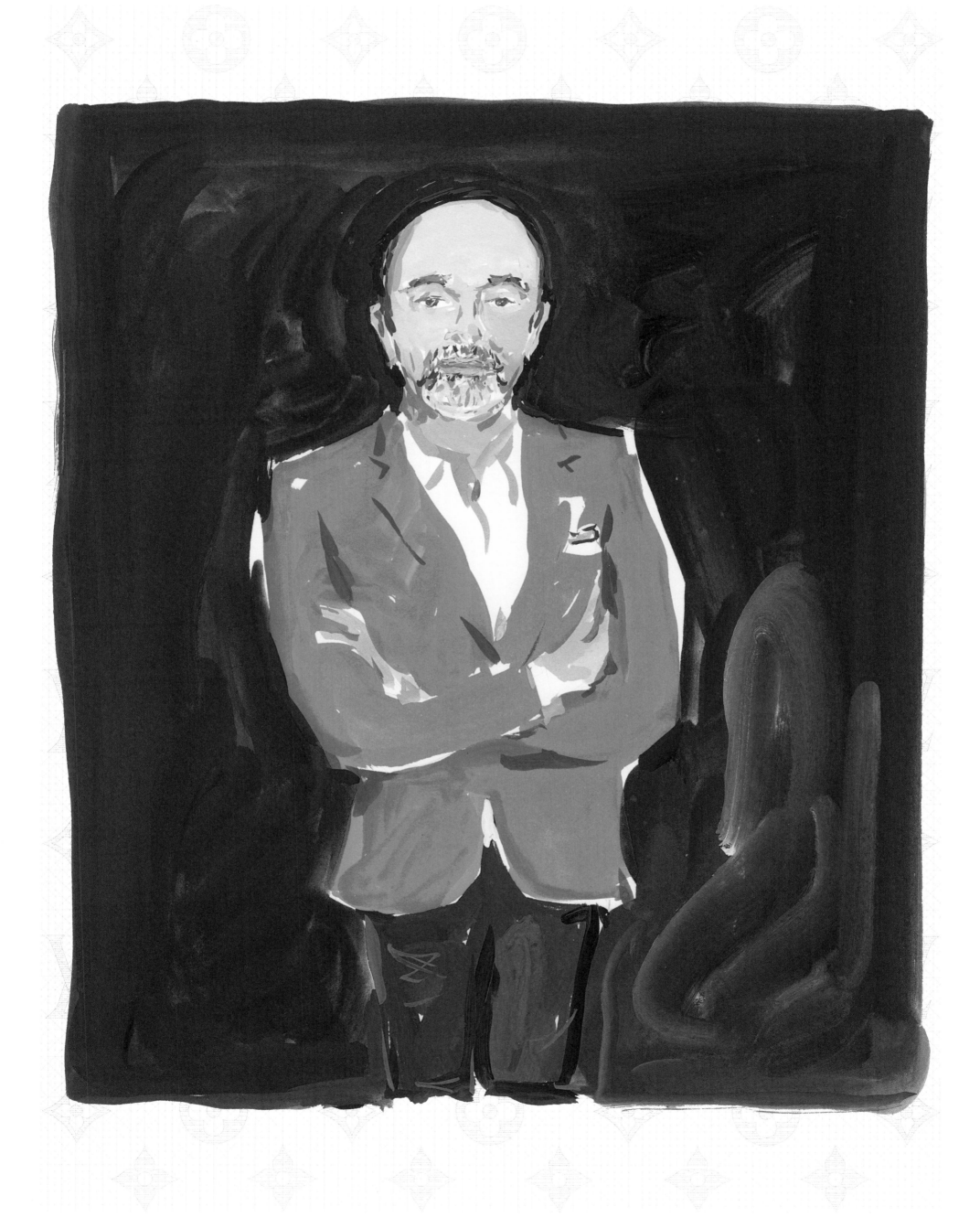

Christian Louboutin by Jean-Philippe Delhomme

CHRISTIAN
LOUBOUTIN

CHRISTIAN LOUBOUTIN grew up for a love of
femininity and a fascination for the iconic
lines of high heels. After teenage years spent
exploring Parisian nightlife and surrounded
by showgirls -- his first job was at the
Folies Bergère cabaret, where he assisted the
entertainers backstage -- he went on to travel
the world. Each of these experiences informs
the aesthetic of the designer to this day.

It has been an iconoclastic route for an
iconoclastic shoe designer, who is now perhaps
the most famous in the world -- alongside that
of his trademark: the red sole.

With little formal training, CHRISTIAN LOUBOUTIN
returned from his travels to find employment
with Charles Jourdan in 1981 and quickly
progressed to the atelier of Roger Vivier.
Freelance stints for Chanel and Yves Saint Laurent
followed, but it was in 1991 that CHRISTIAN
LOUBOUTIN's company was really founded with
the opening of his Paris store.

Since then the designer has gone on to produce
projects as diverse as an exploration of fetish
footwear in collaboration with the filmmaker and
photographer David Lynch and a realization of
Cinderella's slipper for Disney. In 2012 London's
Design Museum hosted a retrospective of the
designer's work.

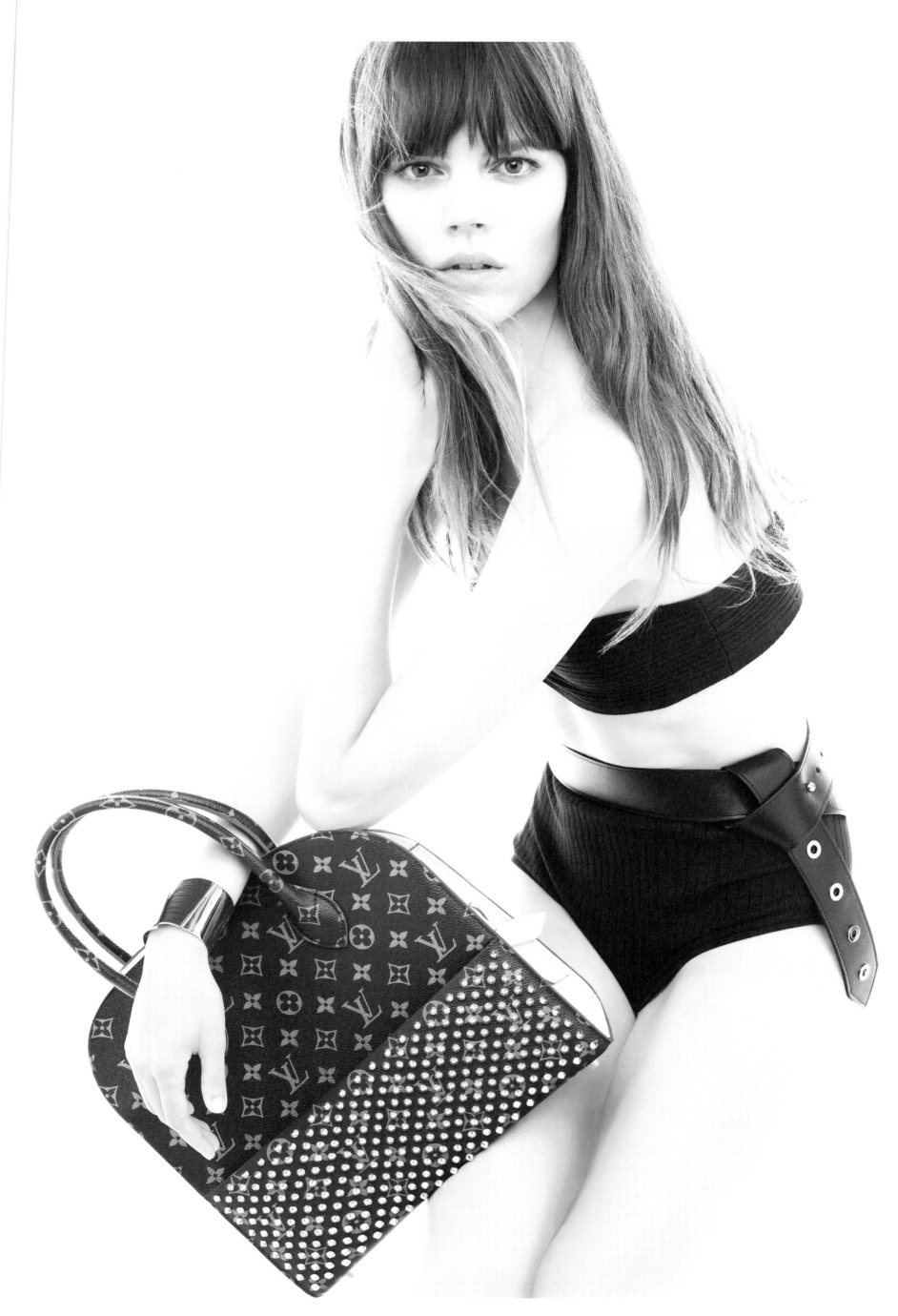

Freja Beha Erichsen photographed by Steven Meisel

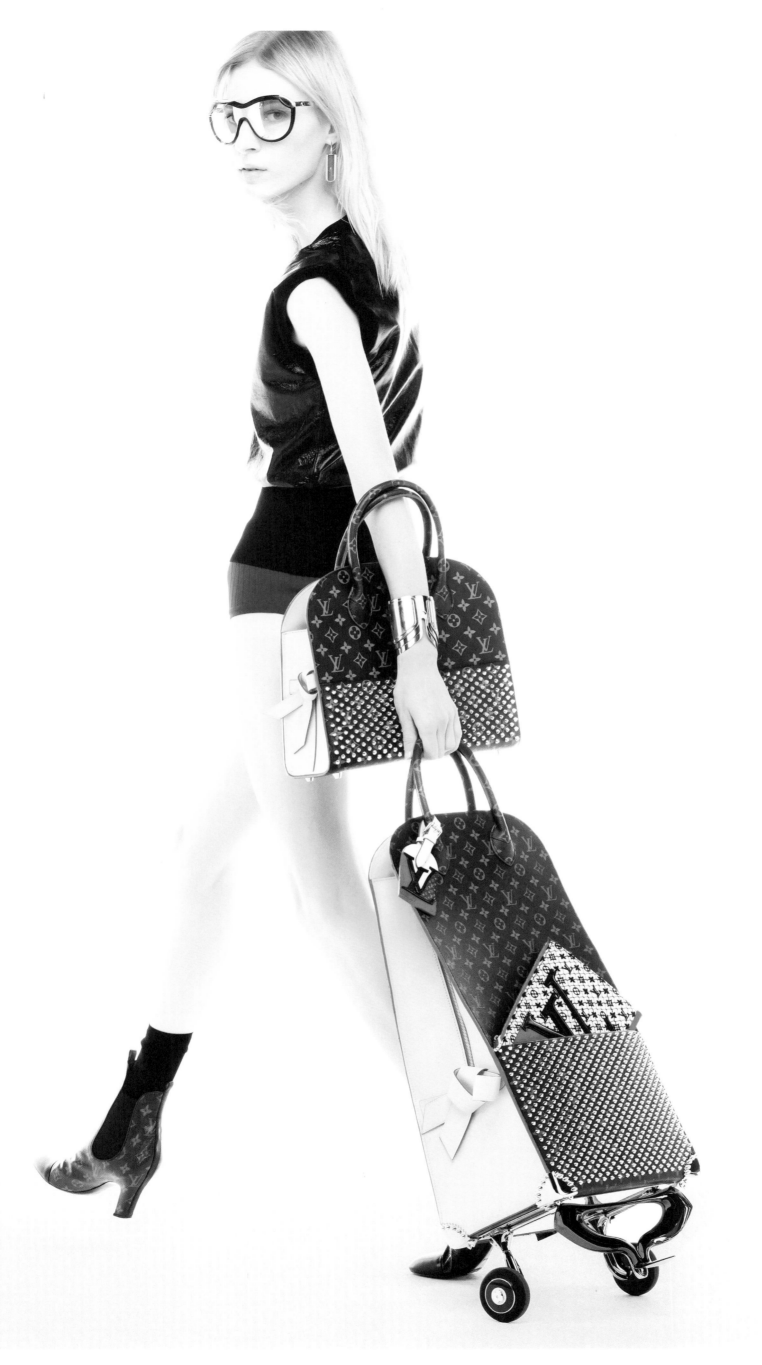

Julia Nobis photographed by Steven Meisel

For me, the bag had to be a combination of two DNAs: my own and
LOUIS VUITTON's. Then I really began to think about what would
be a marriage between the two.

With the MONOGRAM design itself there is the inspiration of
Les Nabis. The influence of those French artists at the end of
the nineteenth and the beginning of the twentieth century was great.
In turn Les Nabis themselves were influenced and inspired by Japanese
art. What I thought I would have to carry on my side was the very
French, very Parisian influence. I was born and raised in Paris,
so I thought about something that would be unmistakably Parisian
for me. This is how the idea of the trolley came about. The bag
evokes the sight of somebody shopping in the markets of Paris
-- I once tried to count the numbers of caddies I met in two hours
at a Parisian market: 109!

Then I started to think about the layering of these codes --
both LOUIS VUITTON's and mine. The idea of lacquer occurred to me,
especially in connection with Les Nabis and the influence of Japan
in their work. It was the marriage of colors and the marriage of
influences; on LOUIS VUITTON's side the influence of Les Nabis on
the MONOGRAM and their debt to Japan; on my side, being very French
but also looking at something very Japanese and coming from my
trademark -- the red sole -- the idea of red lacquer. Of course,
I had to have the red touch!

As for the person who would use the bag, for some reason I was
seeing the kind of girl that I often recognize in Los Angeles.
These girls generally never venture out in the streets, but when
they do, they wander around -- with their perfect skin -- at these
vast organic markets. It is such a scene. I was imagining a girl in
Brentwood doing her shopping with the caddy and, of course, she would
be on her phone. Do I also see myself dragging the caddy around a
Parisian market? Well, yes… but on a sunny day!

CHRISTIAN LOUBOUTIN

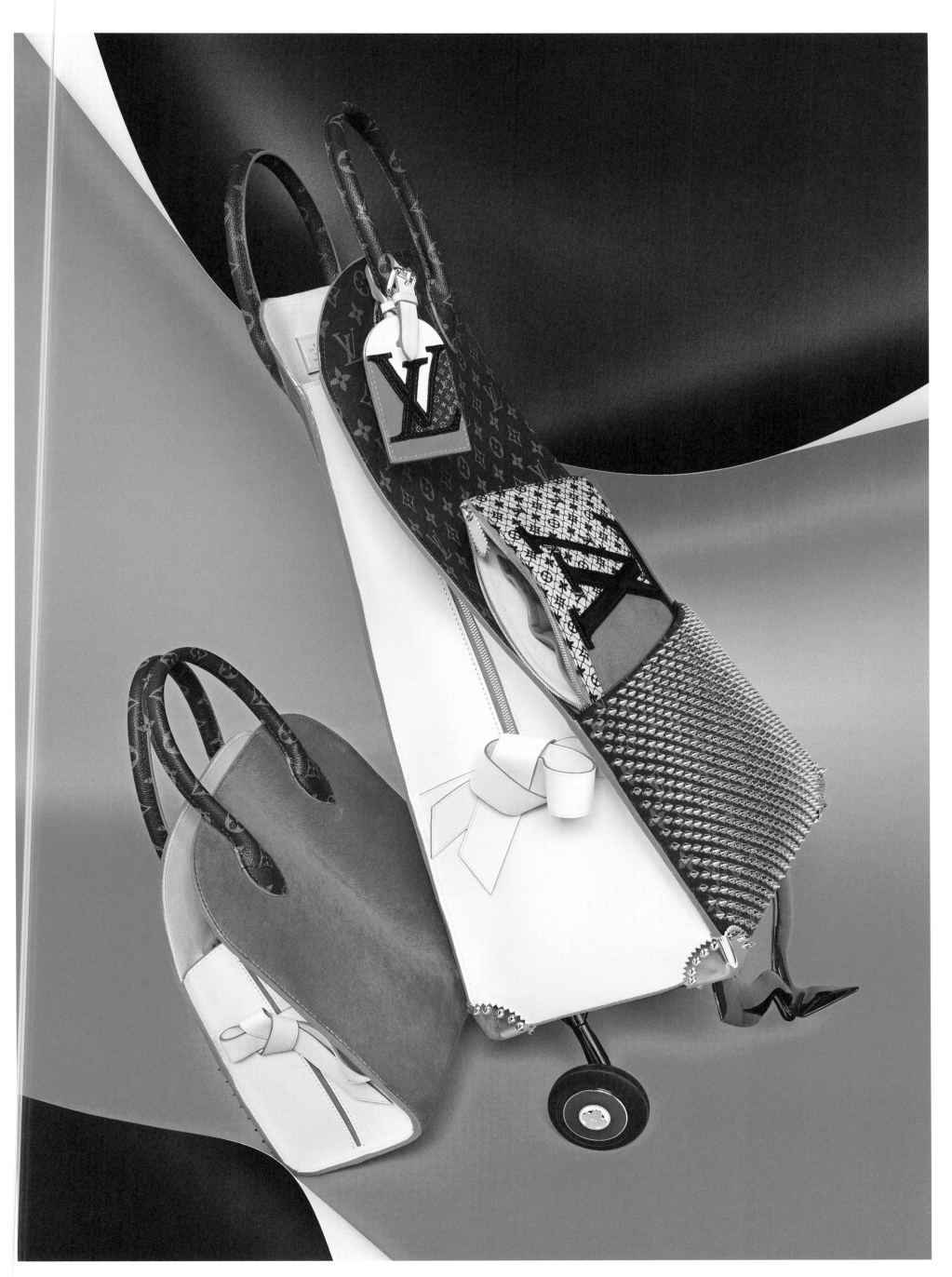

Christian Louboutin bag, trolley and pochette photographed by Erwan Frotin

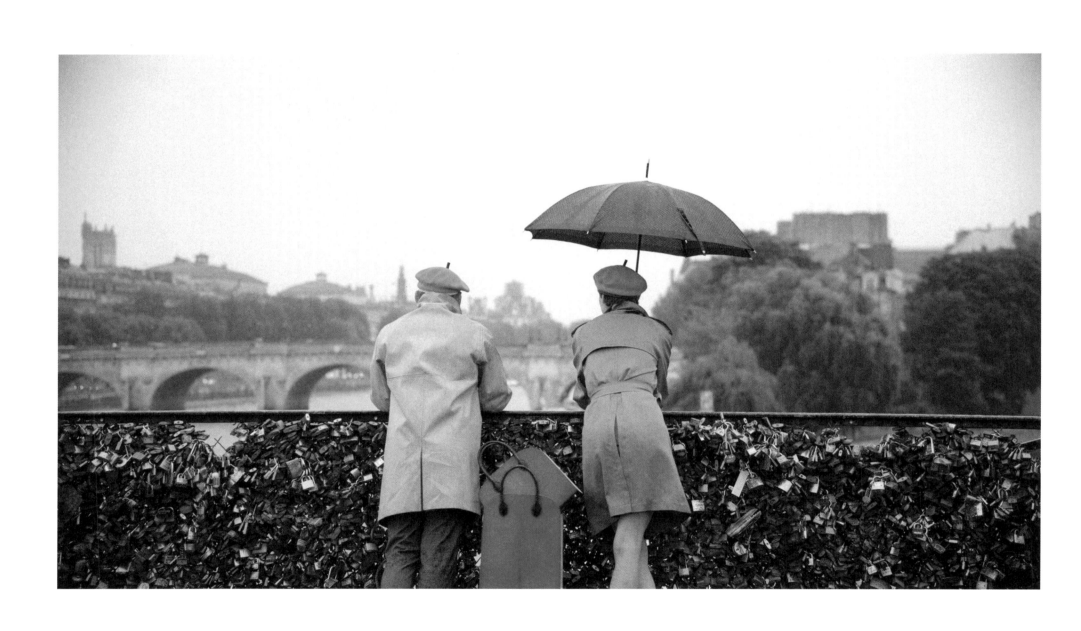

Christian Louboutin and Saskia de Brauw in a film by Gordon von Steiner

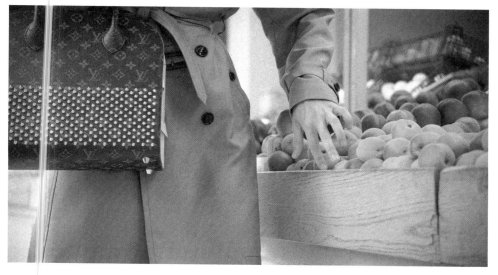
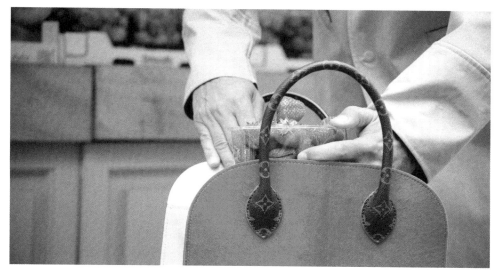
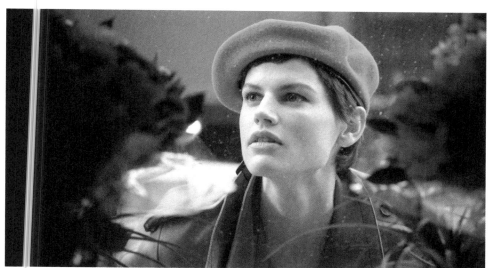

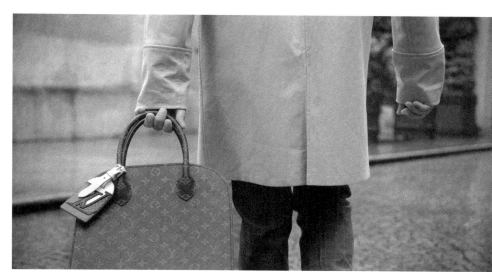
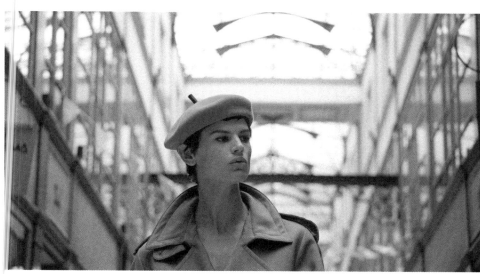
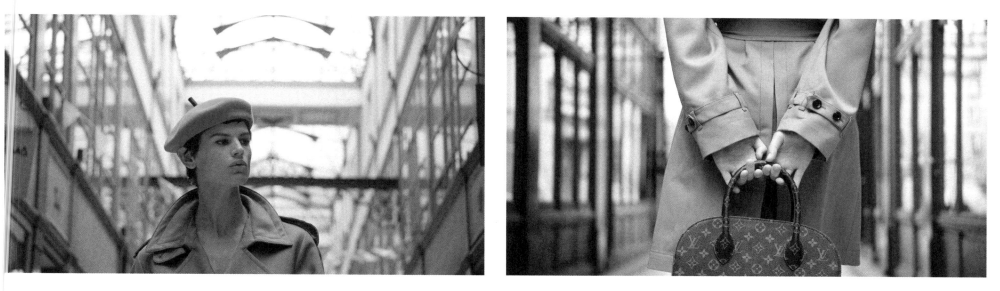

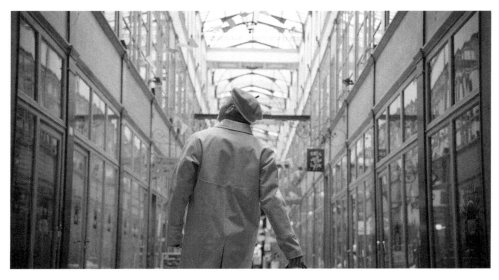
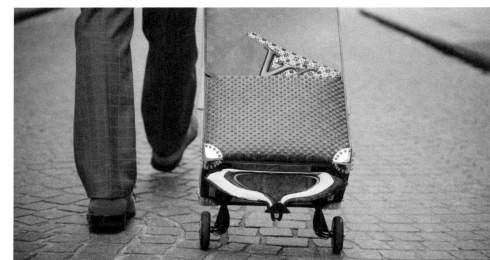
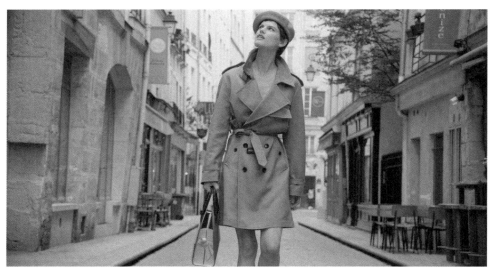
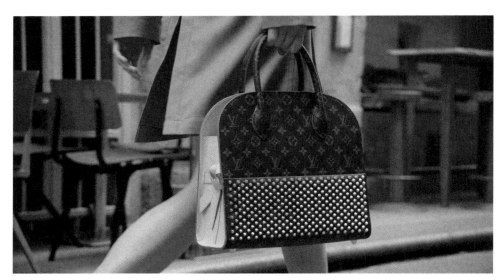
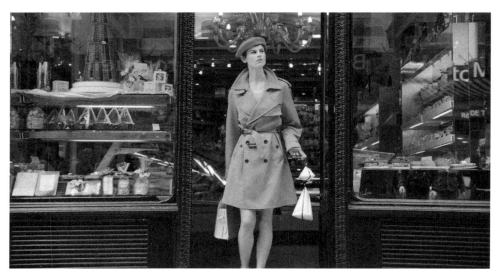
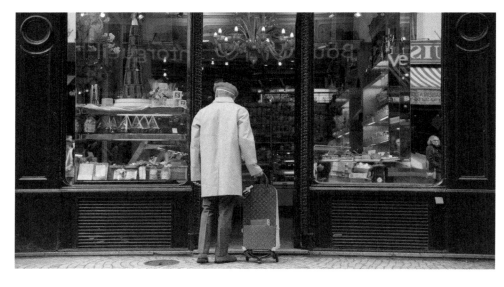
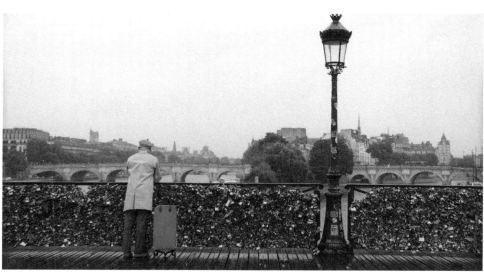
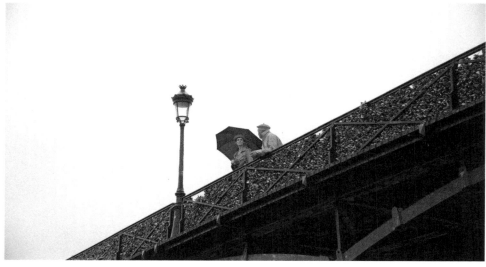

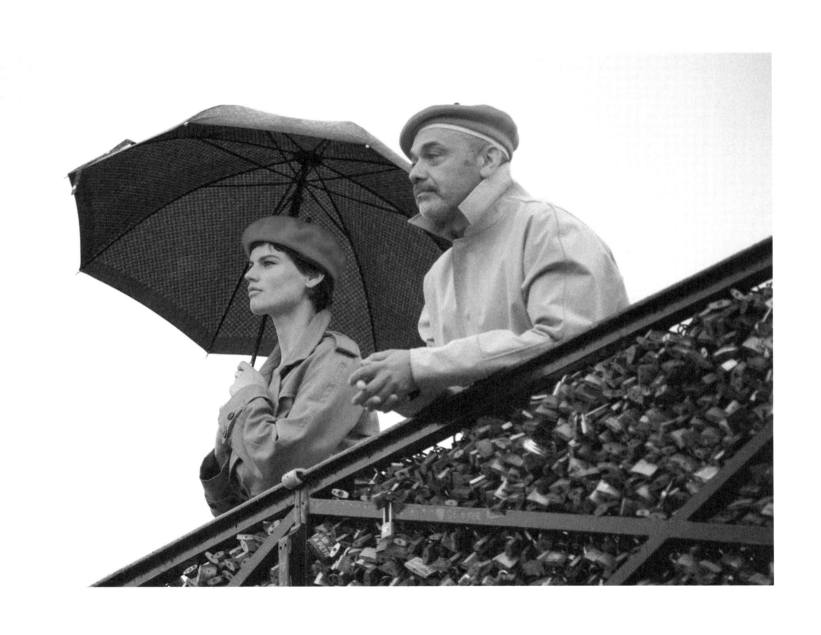

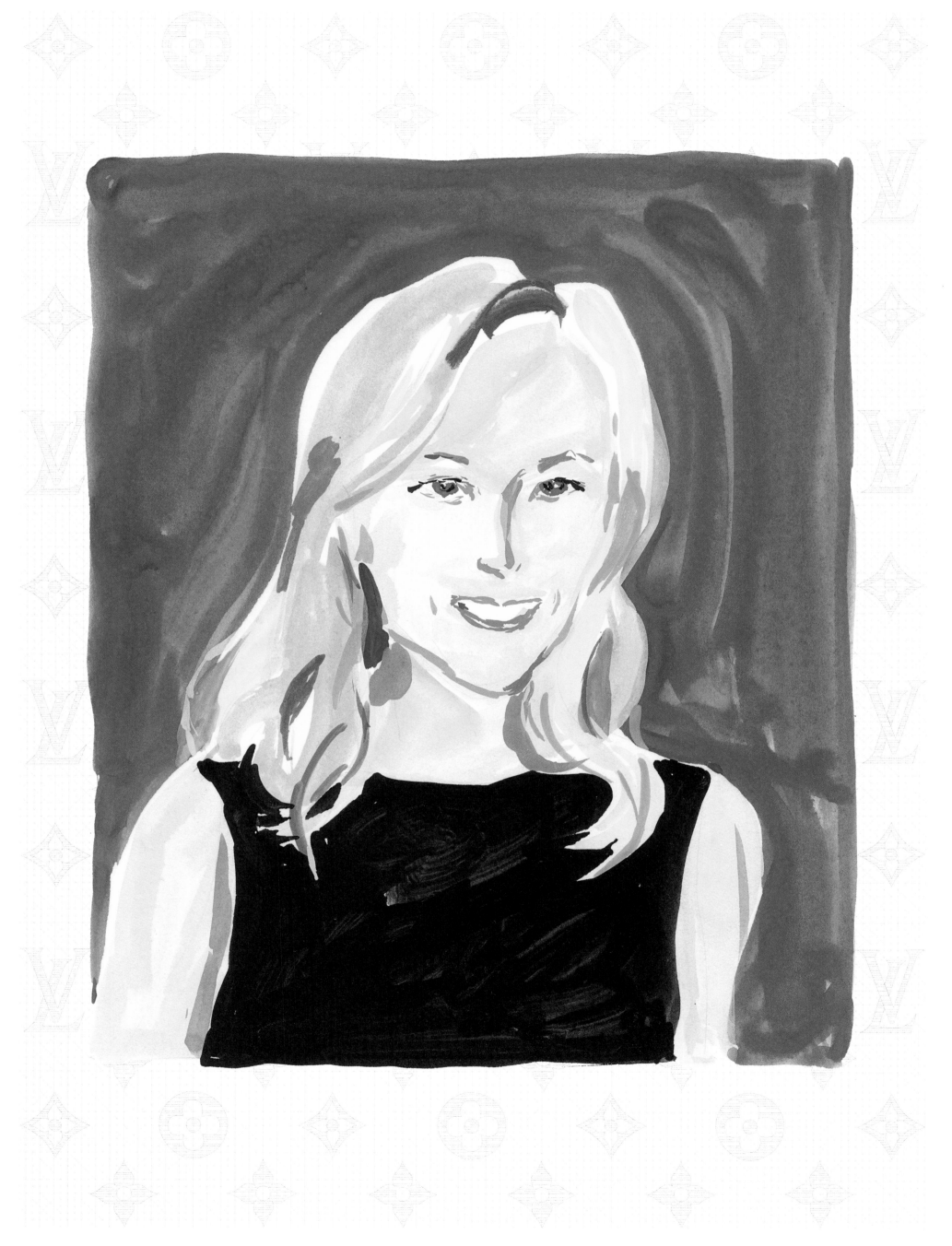

Cindy Sherman by Jean-Philippe Delhomme

CINDY
SHERMAN

Since the mid-1970s, CINDY SHERMAN has redefined
boundaries as an image-maker and filmmaker.
Using herself as a character actress/model/
wardrobe mistress/make-up artist/hairstylist/
director/author/cinematographer and photographer,
CINDY SHERMAN is arguably the greatest living
female artist.

Best known for her photographic portraits,
where SHERMAN herself assumes the role of
different individuals, both female and male,
she frequently presents herself as an icon,
yet iconoclastically questions the role of
women in the media.

CINDY SHERMAN approaches her subject matter
through the use of borrowed visual forms.
Here, the film still, the centerfold, the fashion
photograph, the historical portrait and the
soft-core sex image have all been utilized
by the artist.

Exhibited widely and internationally —— including
a retrospective at the Museum of Modern Art
in 2012 —— CINDY SHERMAN was the recipient of
the prestigious MacArthur Fellowship in 1995,
the so-called "Genius Award." She is also the
proud owner of a parrot.

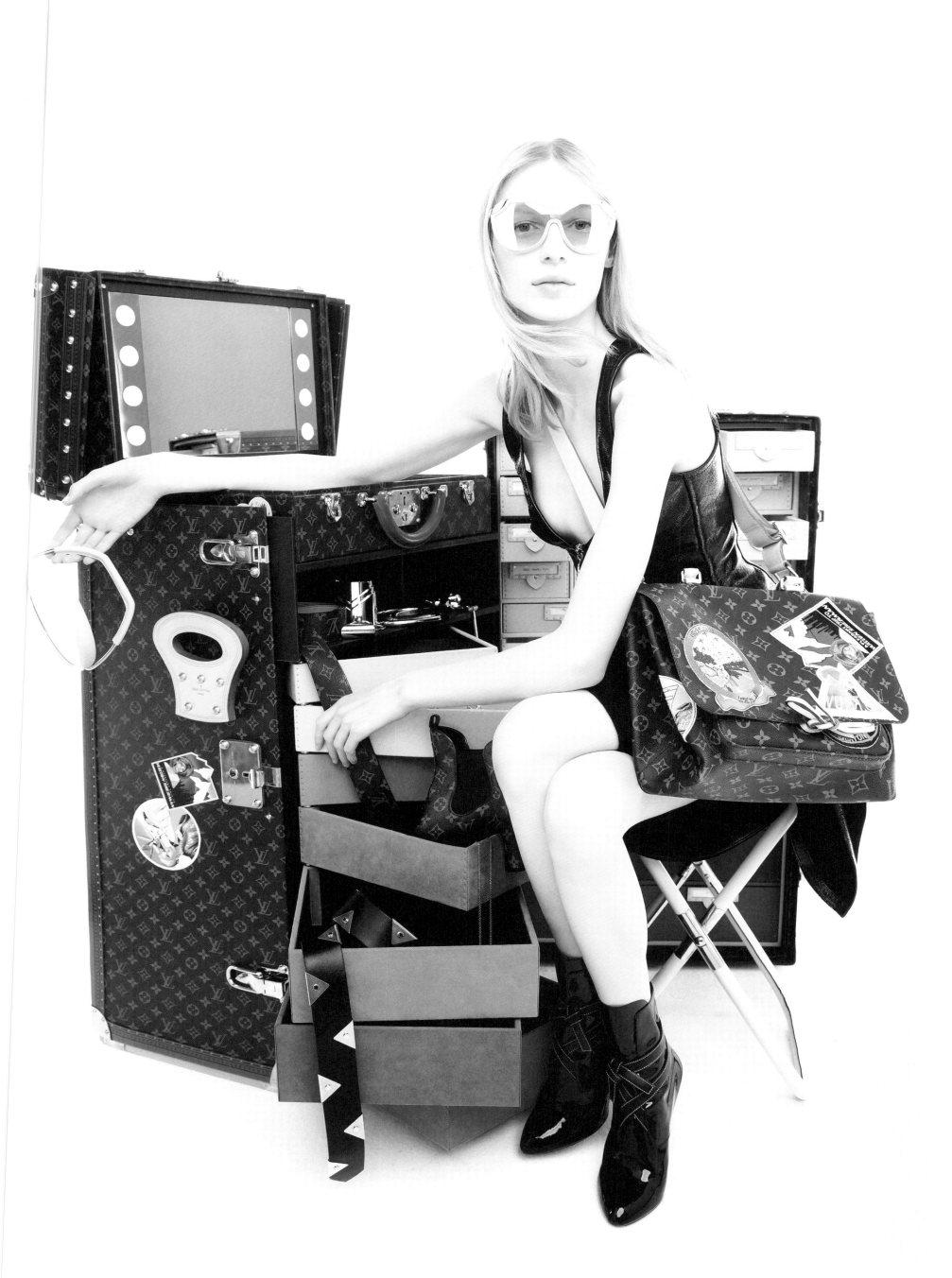

Julia Nobis photographed by Steven Meisel

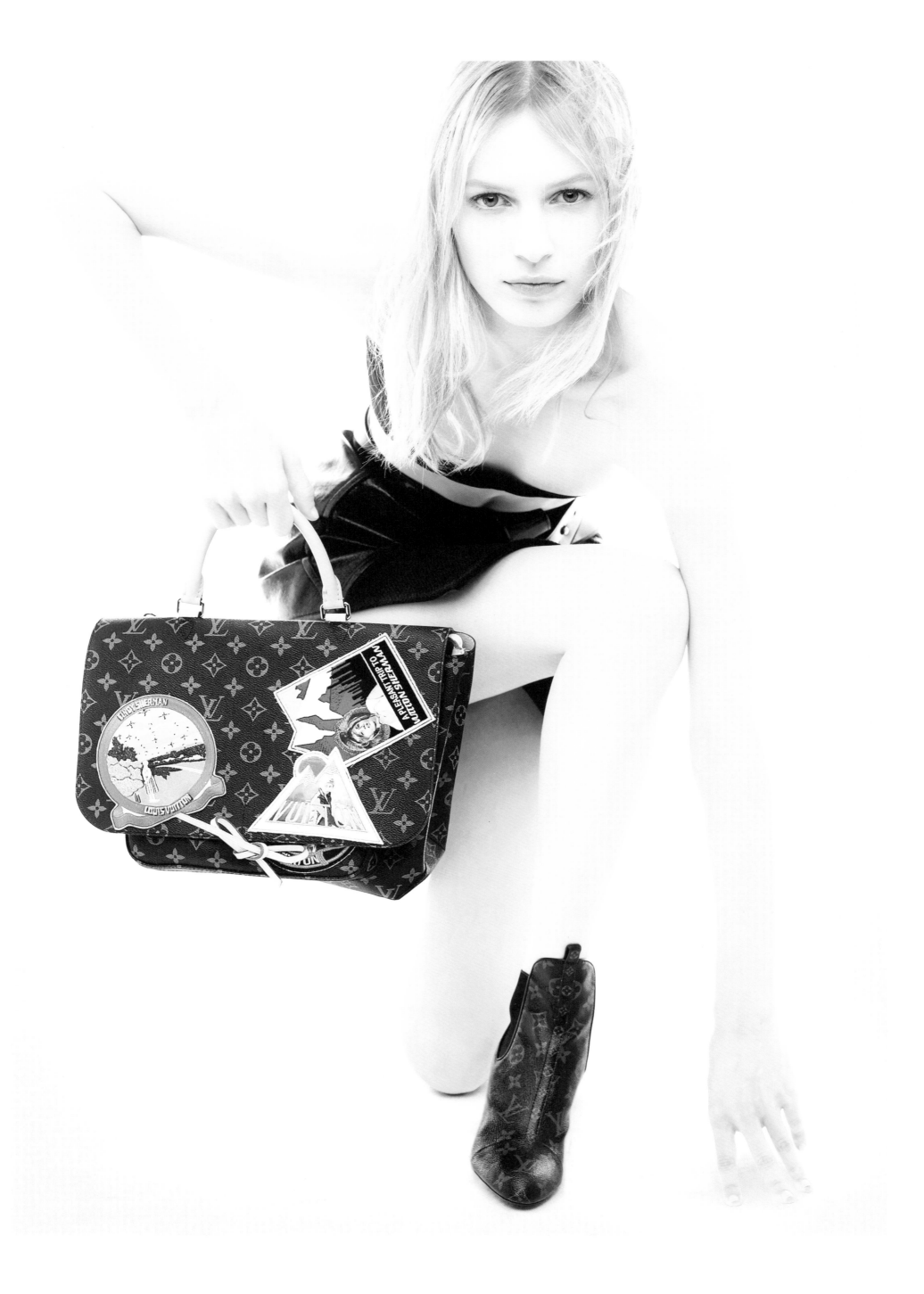

Yes, it is true; I just really wanted the trunk myself! I guess when
LOUIS VUITTON initially talked to me about the project I was in Paris;
I am renting an apartment there now. At first I thought I just don't have
time to do any new projects. Then I thought about my apartment, and realized
I did need a decent place to do my makeup. Originally, I thought it would be
something like an old-fashioned vanity case that I could travel with.
Then LOUIS VUITTON came back to me with the suggestion of a trunk — which
was way more than I initially thought, but I just said *"Yes!"*

The trunk is just so personal to me; I have handwritten labels for all of
the compartments: fake eyeballs, fake teeth… Who else is going to use those?
Fake nails, fake eyelashes… I do have filing cabinets in my studio with all
of this stuff in them. I tried to copy the categories I already have: small
jewellery, pearly stuff, hair accessories, lips, noses, wigs… Of course,
anybody could put his or her underwear or t-shirts inside instead.

I was asked about the color scheme; what was my favourite color? It was
then I thought about my parrot. My parrot is this sort of iridescent green
and there are all of these other colors when he spreads his wings; this
became the color scheme for the interior. I thought it would be nice to have
a reminder of him in Paris. Every whim of an idea is in there! I thought
it would be really nice if the outside of the trunk looked old, like it
had travelled around the world with all of these stickers on the MONOGRAM.
We decided to use some of my images for the stickers, but to push them and
make them more bizarre. I loved the direction of this… All of it was just
so much fun to do!

With LOUIS VUITTON, I talked about all of the other things inside the
trunk that could be pulled out and used. In the end the vanity case was
incorporated — it is a small suitcase that can be removed from the top.
Everything was so conscientiously designed, even down to my height — I sat
on the little stool and it was checked where my eyes would be in the mirror.
Then I said, *"How about a camera bag?"* I shoot when I am on the road;
I have been shooting backgrounds for some of my more recent work, these
become digitally inserted into final pieces. That idea became the separate
messenger bag.

The trunk could be a mini-traveling studio and I liked that option.
It certainly will be a lot easier now to contemplate that idea — I have
never really traveled for work. This way it will be great, it means I can
have an extra camera in Paris and duplicates of props — with the trunk it
means theoretically I can even take other little trips.

I have made functional things before in my work, but the trunk is the
first non-photographic project I have ever done. I imagine that a Saudi
Arabian princess might use it. I would love if Madonna or Lady Gaga might
consider it — or it might come in useful for a drag queen! RuPaul or
Justin Vivian Bond, he deserves one.

 CINDY SHERMAN

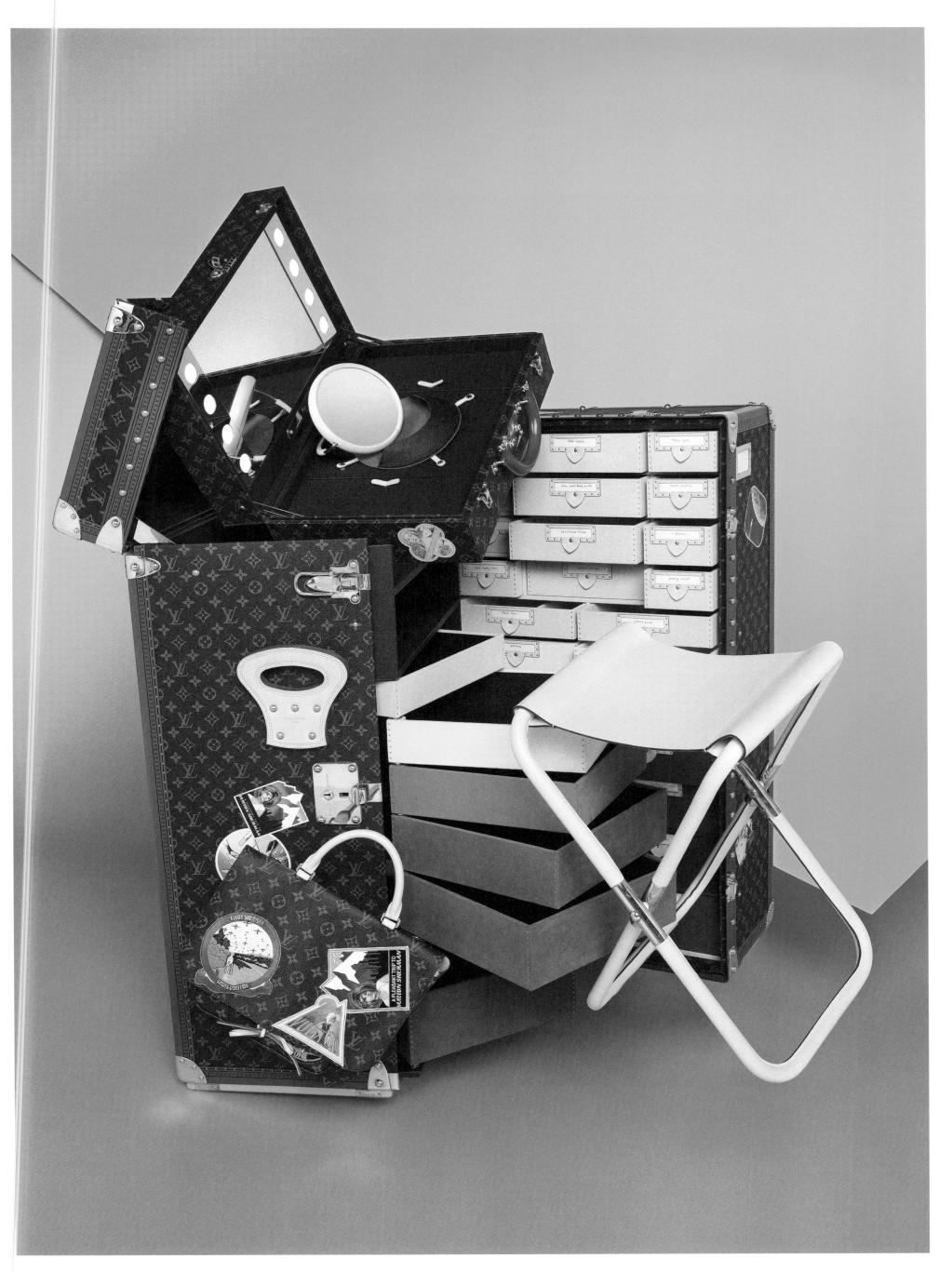

Cindy Sherman trunk and bag photographed by Erwan Frotin

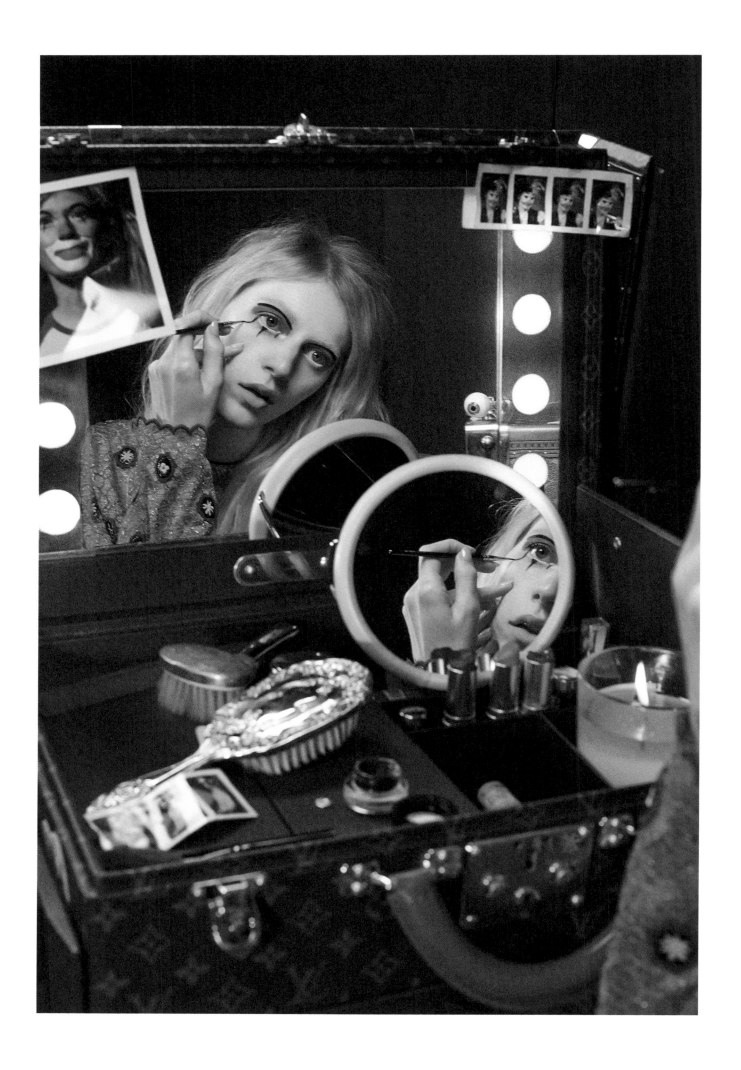

Julia Nobis photographed by Johnny Dufort

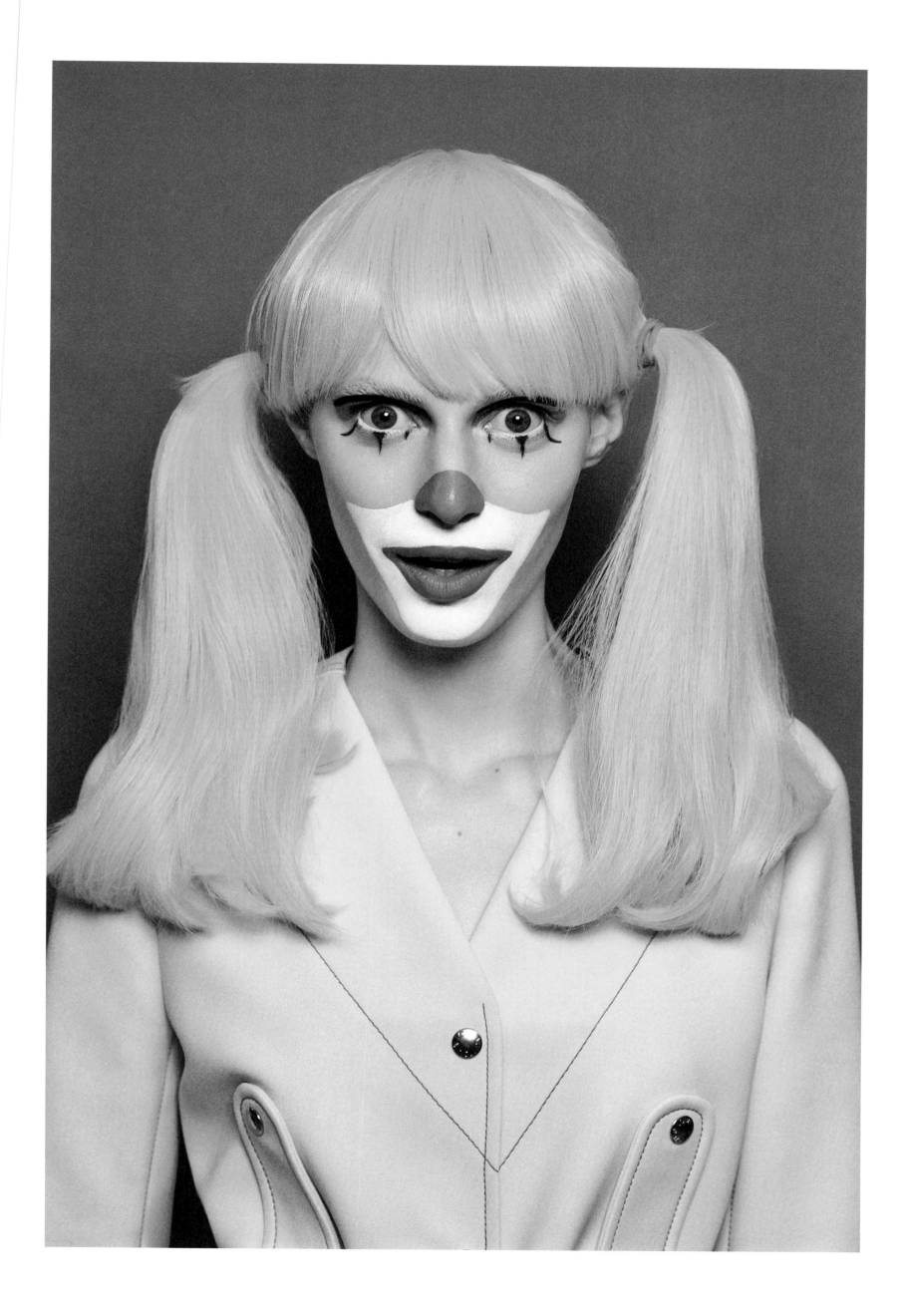

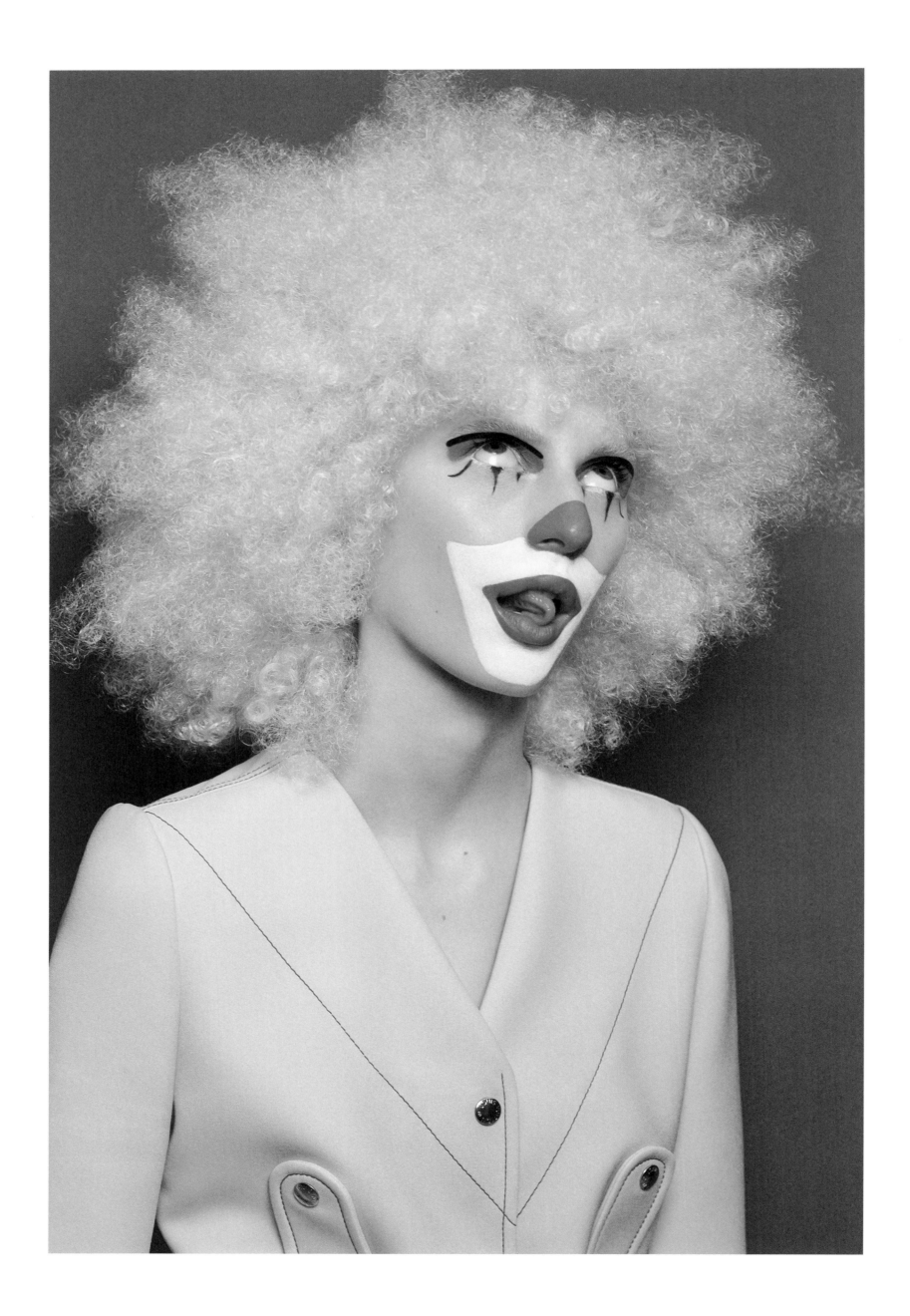

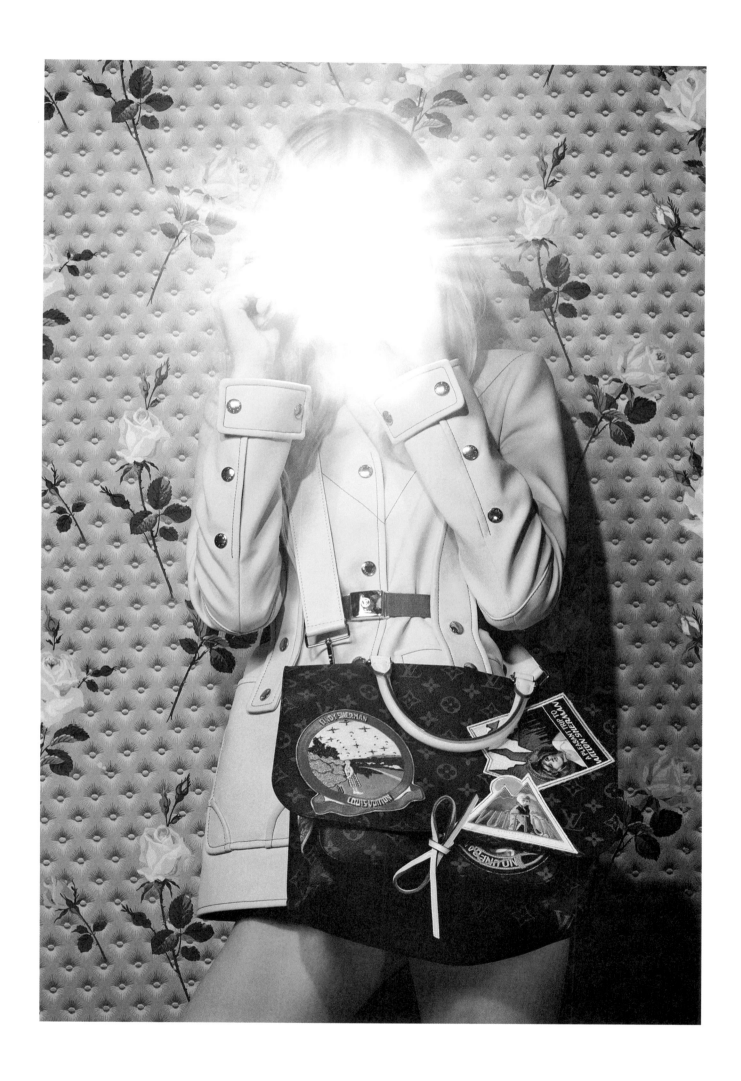

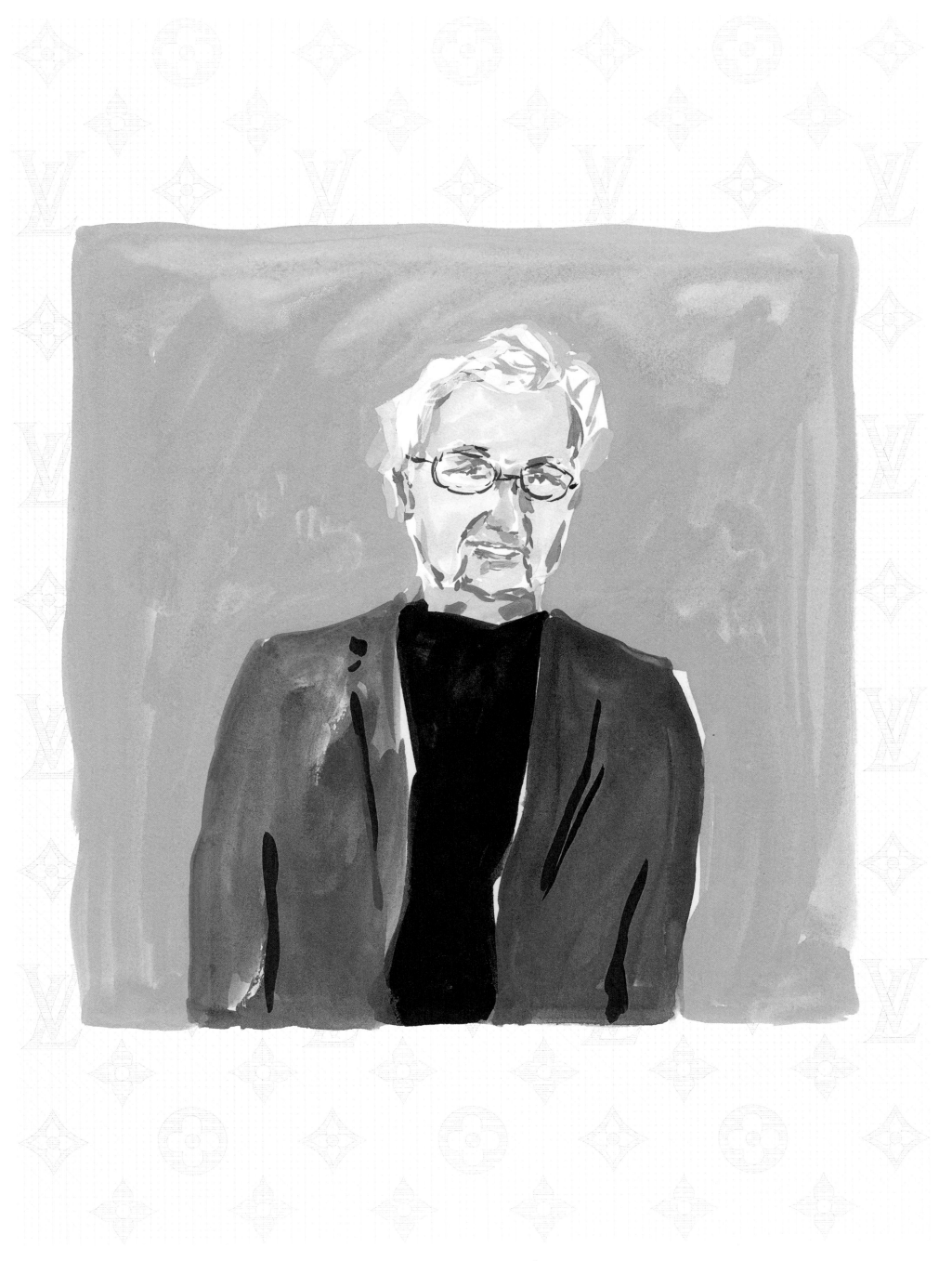

Frank Gehry by Jean-Philippe Delhomme

FRANK
GEHRY

Going beyond existing ideas of structural
definition, utilizing the unexpected and
everyday, making humble materials such as
plywood, chain-link, and corrugated metal siding
into forms simultaneously spectacular and modest,
FRANK GEHRY could perhaps be seen as the ultimate,
iconoclastic architect at work today.

Since establishing his architectural practice
in Los Angeles in 1962, FRANK GEHRY has produced
some of the world's most important and famous
buildings, themselves becoming icons of our era.
From his own startling renovation of his residence
in Santa Monica, purchased and redone in 1977,
to the Guggenheim Museum Bilbao in 1997
-- called by the legendary architect Philip
Johnson, *"the greatest building of our time"* --
FRANK GEHRY has redefined the architectural
landscape.

He continues to do so with numerous prestigious
commissions including his other project due later
this year for LOUIS VUITTON: the FONDATION LOUIS
VUITTON in Paris. *Vanity Fair* has called FRANK
GEHRY, *"the most important architect of our age."*
He has also voiced himself on *The Simpsons*.

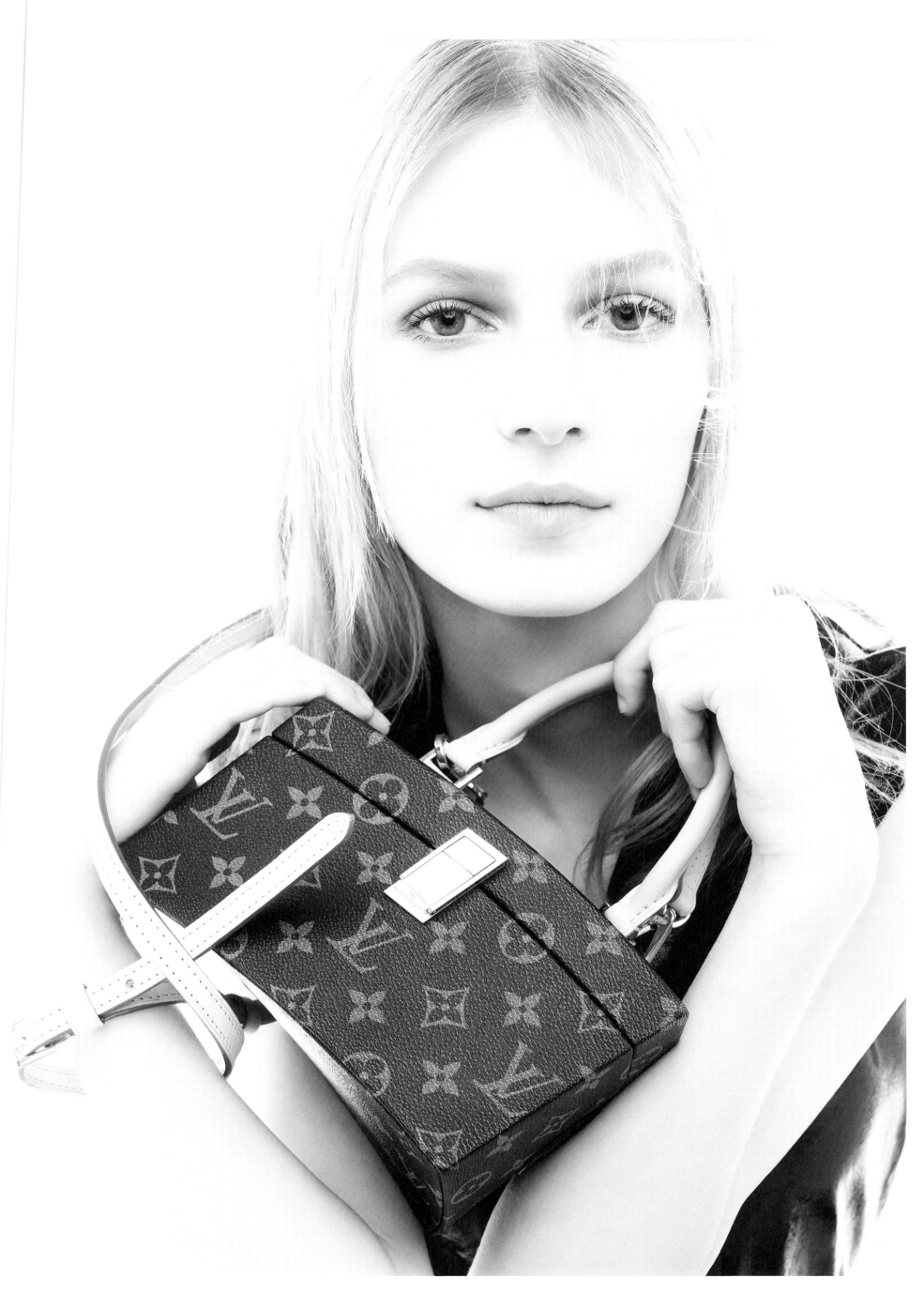

Julia Nobis photographed by Steven Meisel

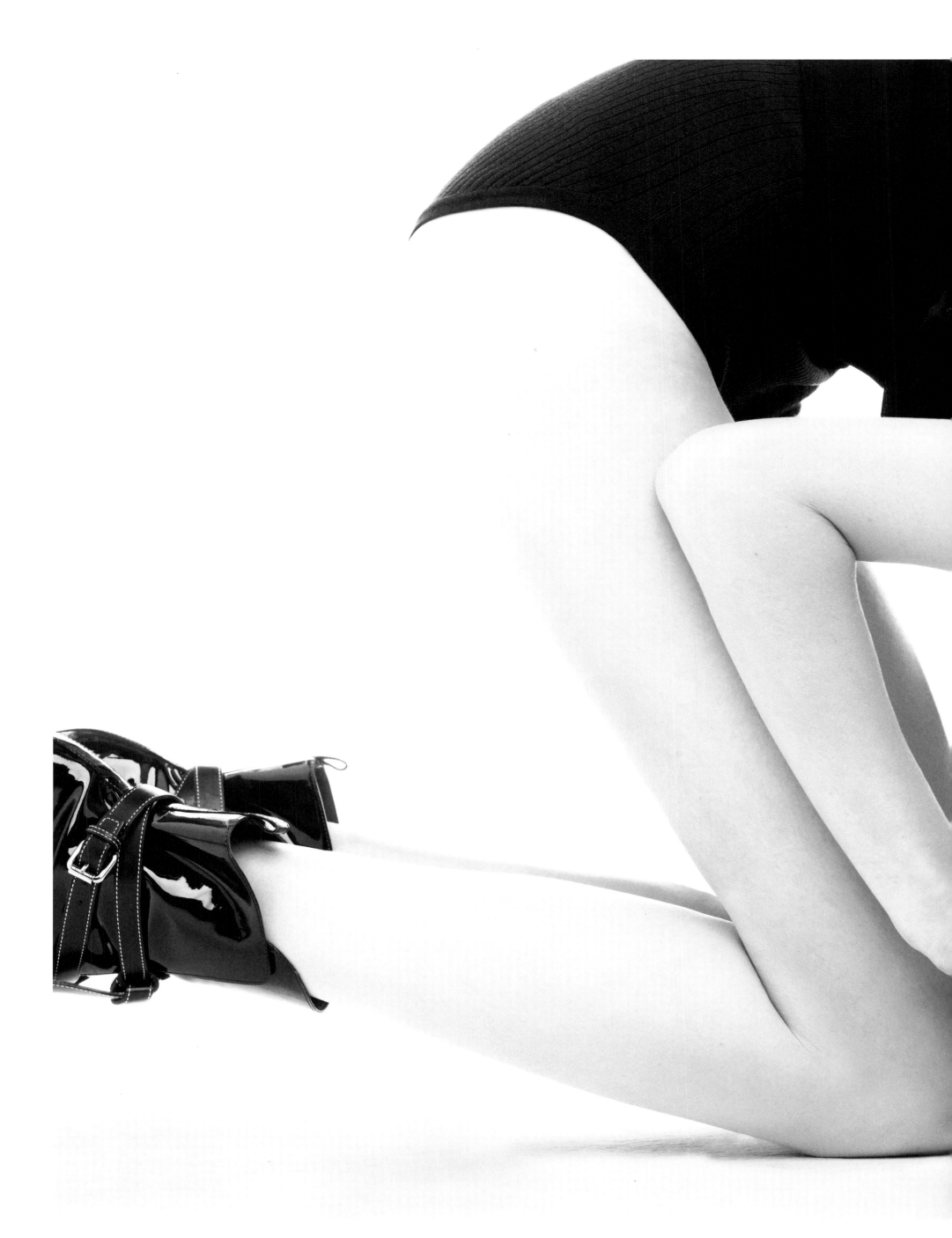

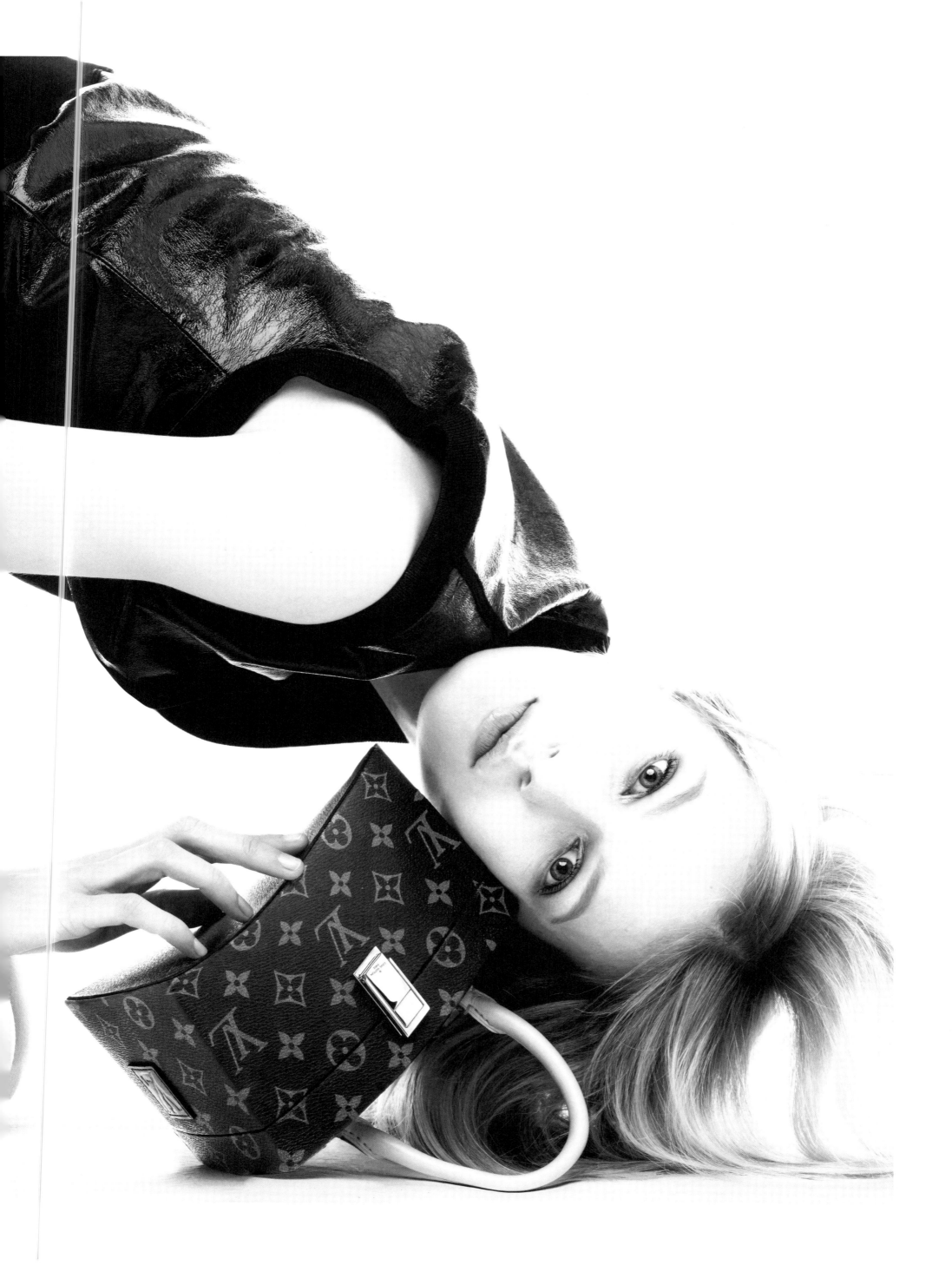

It just all happened seamlessly… I thought *"a handbag."* I think I said to myself
"OK, I'll try and make one." That is always my kind of attitude: let's try.
So I did, and LOUIS VUITTON loved it. I thought *"What is going on?"*

In my work I am usually pushed back if it's new — that's when I know I am
doing OK when I get the push back. With the handbag it was Joyce Shin — a
talented designer who works with me who is also my son's *fiancée* — that helped
with the terrain of it. We started playing with shapes, one of which was this.
I didn't want it to be just "a thing," so I spent time with LOUIS VUITTON to
talk about the refinement of details, the clasp, the whole of it. I have had fun
with them, we have been changing and refining the bag up until the last minute.
They take craftsmanship very seriously at LOUIS VUITTON and that's what I like.

The bag is one thing where it wouldn't have worked being bigger — you
wouldn't make a suitcase that is lopsided, would you? With a handbag you can
get away with it, especially as it sits on a table — that is how I saw it,
sitting like a sculpture. It works as one thing and that's it. I like that
quality about it. I hand drew the MONOGRAM for the embossed interior. I have
never really been inside a handbag, so I was trying to think what I would like
if I was inside, I thought *"maybe blue."* I just liked that colour in contrast
with the brown MONOGRAM. The thing about a handbag is that there is all kinds
of different junk inside, so if I had made the interior reflective, there would
just be more junk! That also called attention to the interior — and I wanted to
leave the attention on the outside. The interior is more private, and a darker
blue just felt more orderly somehow, that it would give the things in the bag
more clarity. I suppose I just have a fantasy of what it would be like to be
inside the bag!

It all happened intuitively, it was not contrived. If I set out to design
a handbag that fits in LOUIS VUITTON's world, and works with LOUIS VUITTON's
customers, I think it would be contrived. This bag is playful, the experience of
making it was playful, but in a serious way. I imagine there would be a lot of
"establishment" architects that would be snooty about me designing a handbag.
That's the best part!

I'll tell you who I would like to see carry it, Queen Elizabeth. Because her
mother carried a little white bag and my mother thought she was the Queen Mother
when she got older, she carried a little white bag too. We had relatives in
England who would talk about going to the Queen's garden party — making her
think that this was a special invitation that her relatives alone received. She
got into the fantasy that she was part of this pseudo-British-royalty-bullshit
and she carried the white purse. We even called her the Queen Mother.
So, really, that was my only experience with handbags.

A bag of notoriety that people all over the world would recognize, I was
thinking about that. Could we make it white for the Queen? Yes, we might —
LOUIS VUITTON had done white before with MURAKAMI. So my idea is that we make a
special white one and I go to Queen Elizabeth and I present it to her. I think
she'd be happy to receive it. I might be knighted!

FRANK GEHRY

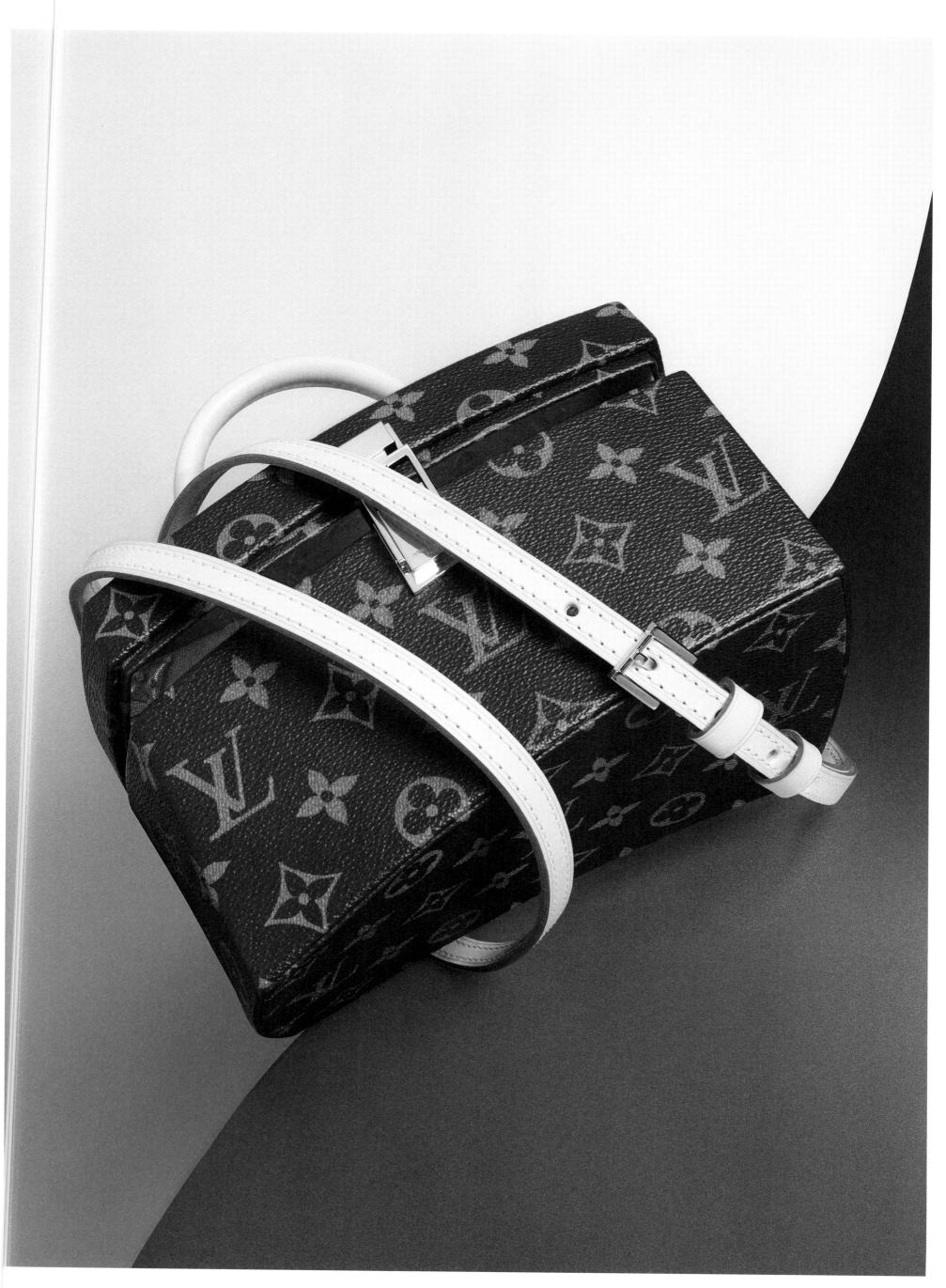

Frank Gehry bag photographed by Erwan Frotin

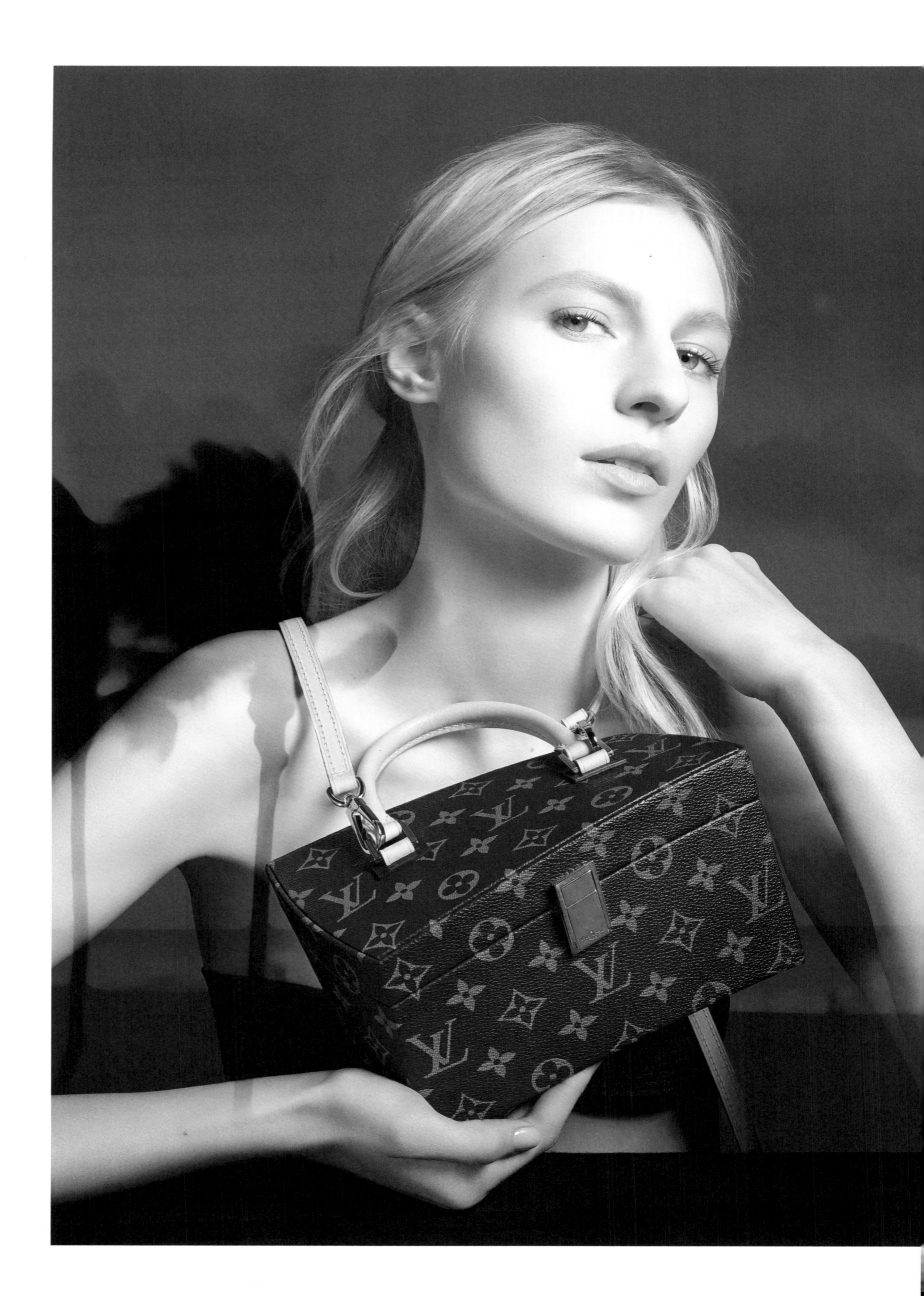

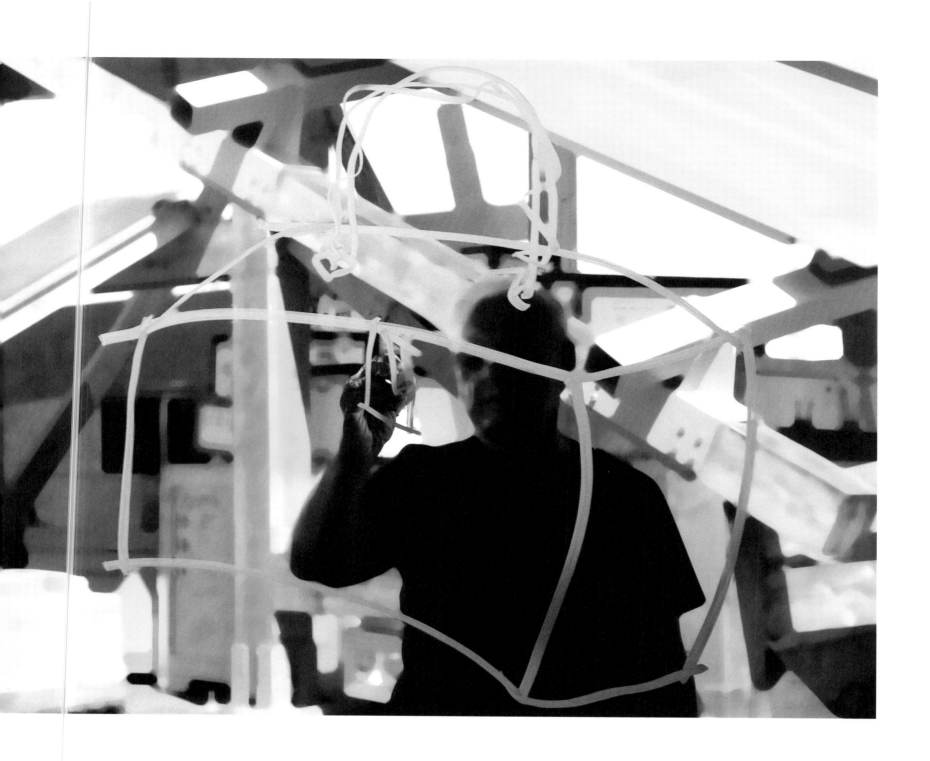

Julia Nobis and Frank Gehry in a film by Pierre Debusschere

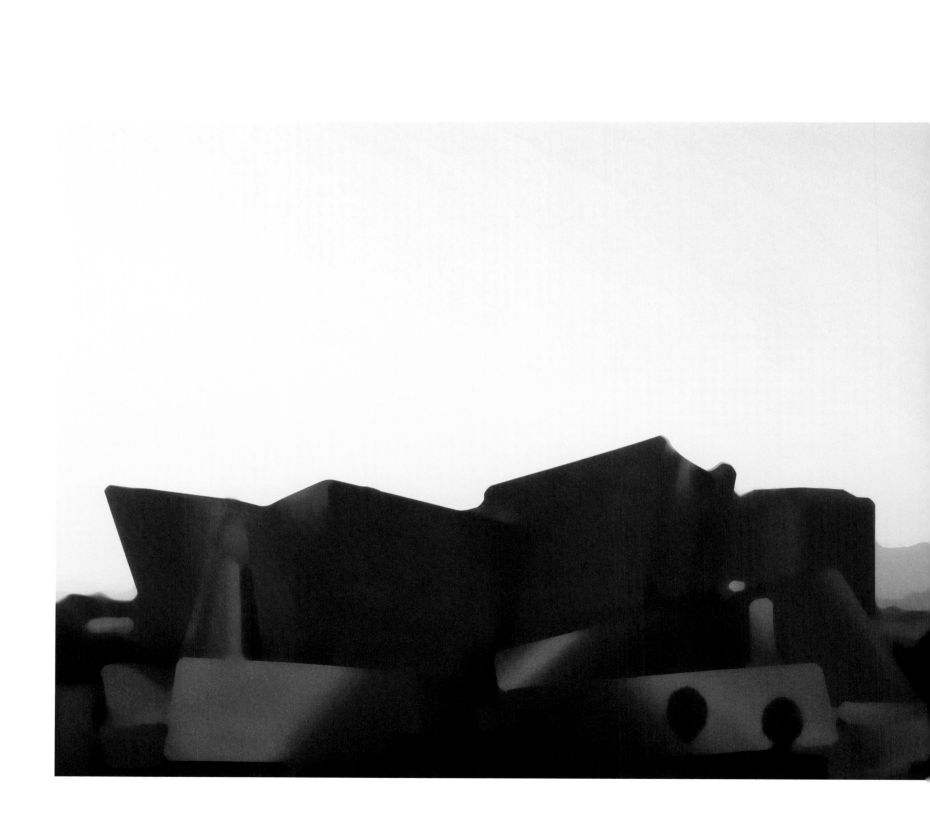

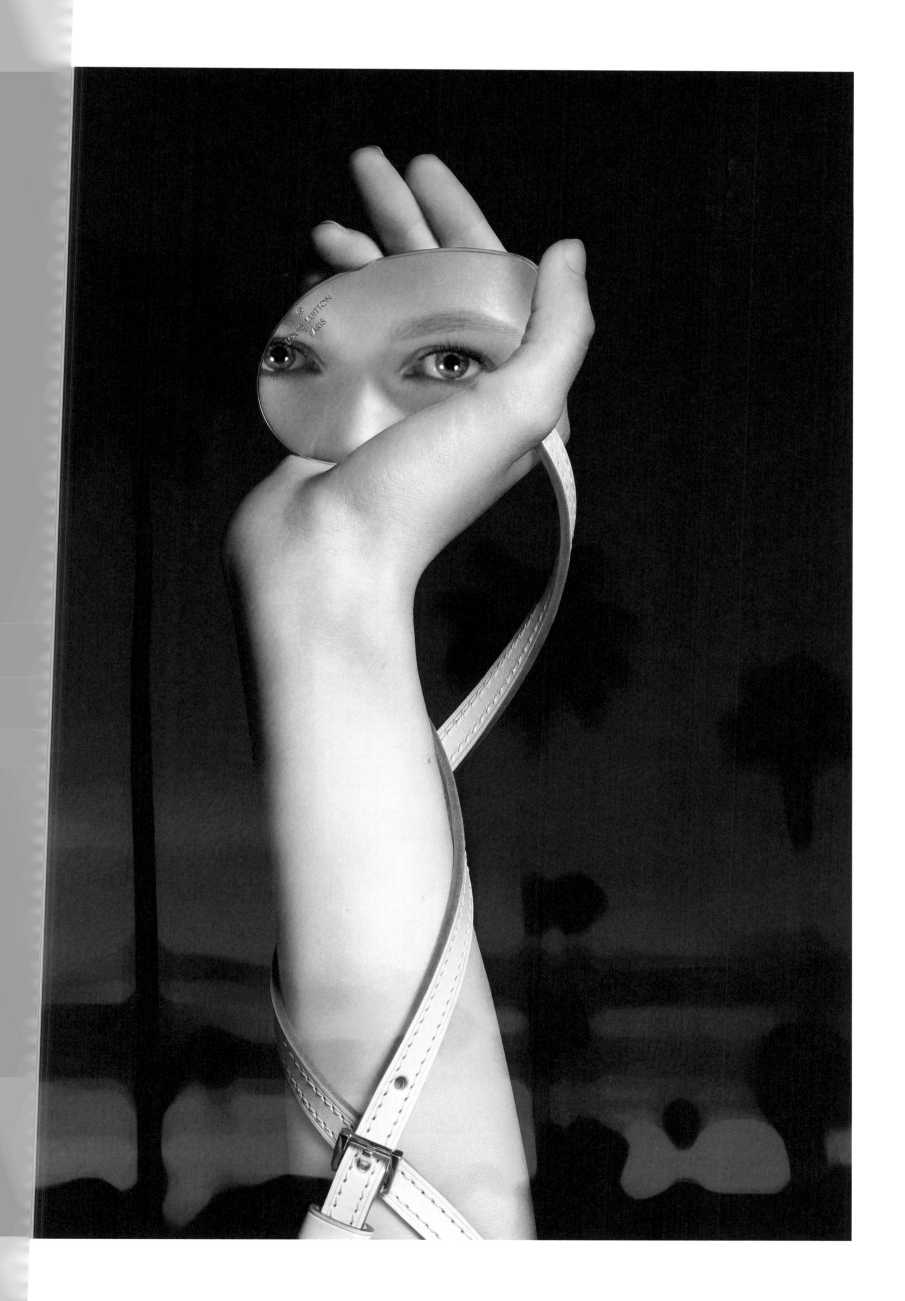

K.L

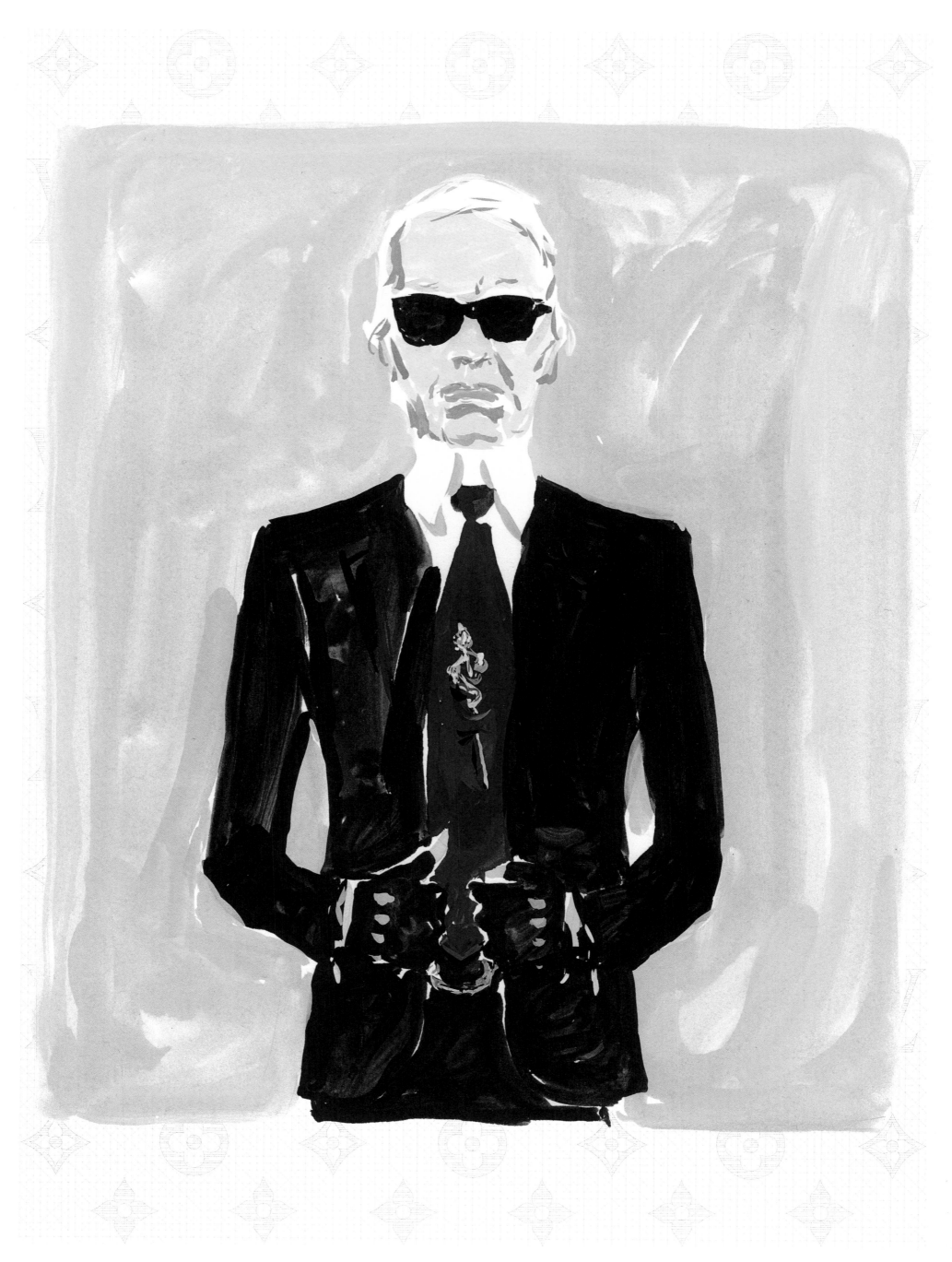

Karl Lagerfeld by Jean-Philippe Delhomme

KARL
LAGERFELD

As a fashion designer and creative director, it
is not an over-estimate to say that KARL LAGERFELD
has revolutionized his field. His iconoclastic
approach to redefining fashion, particularly
predicting and understanding the importance of
ready-to-wear and knowing how to revitalize and
reinvent brands, could be seen as the blueprint
by which many fashion houses operate today.

Beginning his career at 17 working for
Pierre Balmain and later Jean Patou and Chloé
simultaneously immersed himself in and expanded
his knowledge of history, art, languages,
architecture, music and particularly eighteenth
century French furniture. This has given KARL
LAGERFELD the unusual combination of being a
preeminent designer, fashion trouble-shooter and
contemporary Renaissance man. Collaborating with
Fendi since 1965, and working for many years as
its creative director, has meant that label's
perpetual reinvention and constantly evolving,
contemporary nature. Since 1983, KARL LAGERFELD
has held astonishing tenure as the chief designer
and creative director of the house of Chanel.

A true icon in his own right, as well as an
iconoclast, KARL LAGERFELD never rests -- amongst
other pursuits he heads his own house, is an
accomplished photographer, sits on the LVMH
Prize jury in search of young talent, is a book
publisher and is the proud owner of a cat.

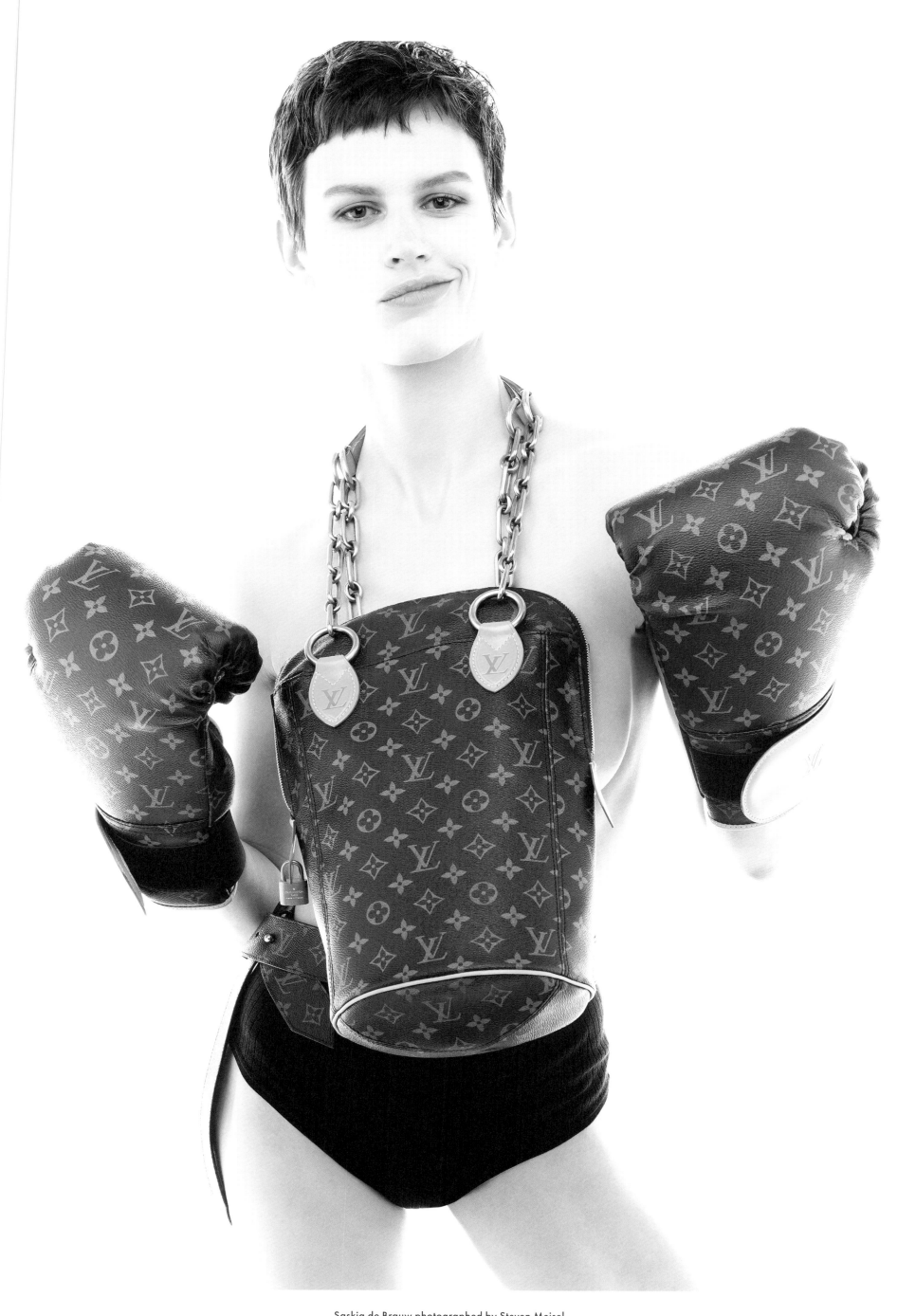

Saskia de Brauw photographed by Steven Meisel

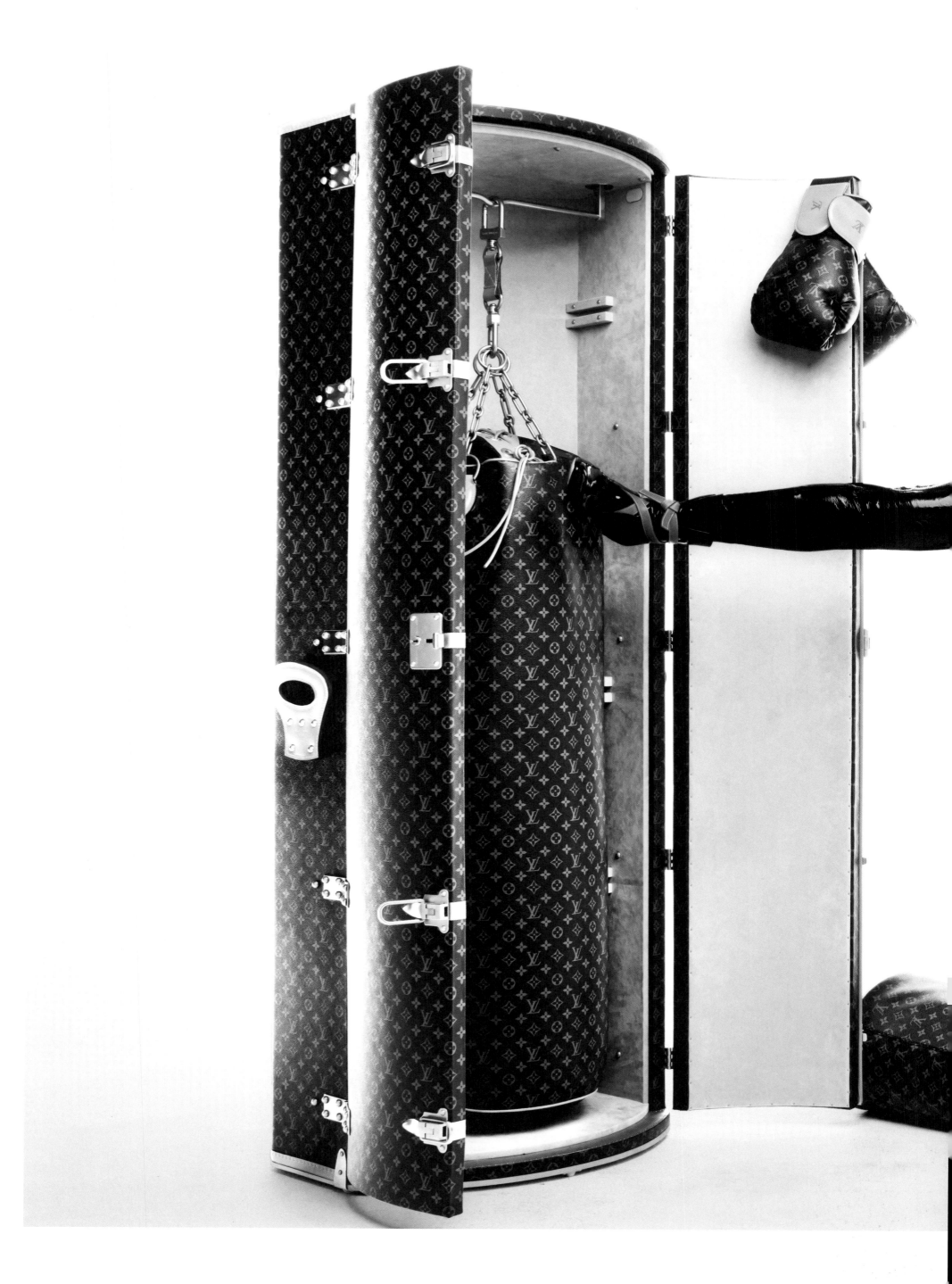

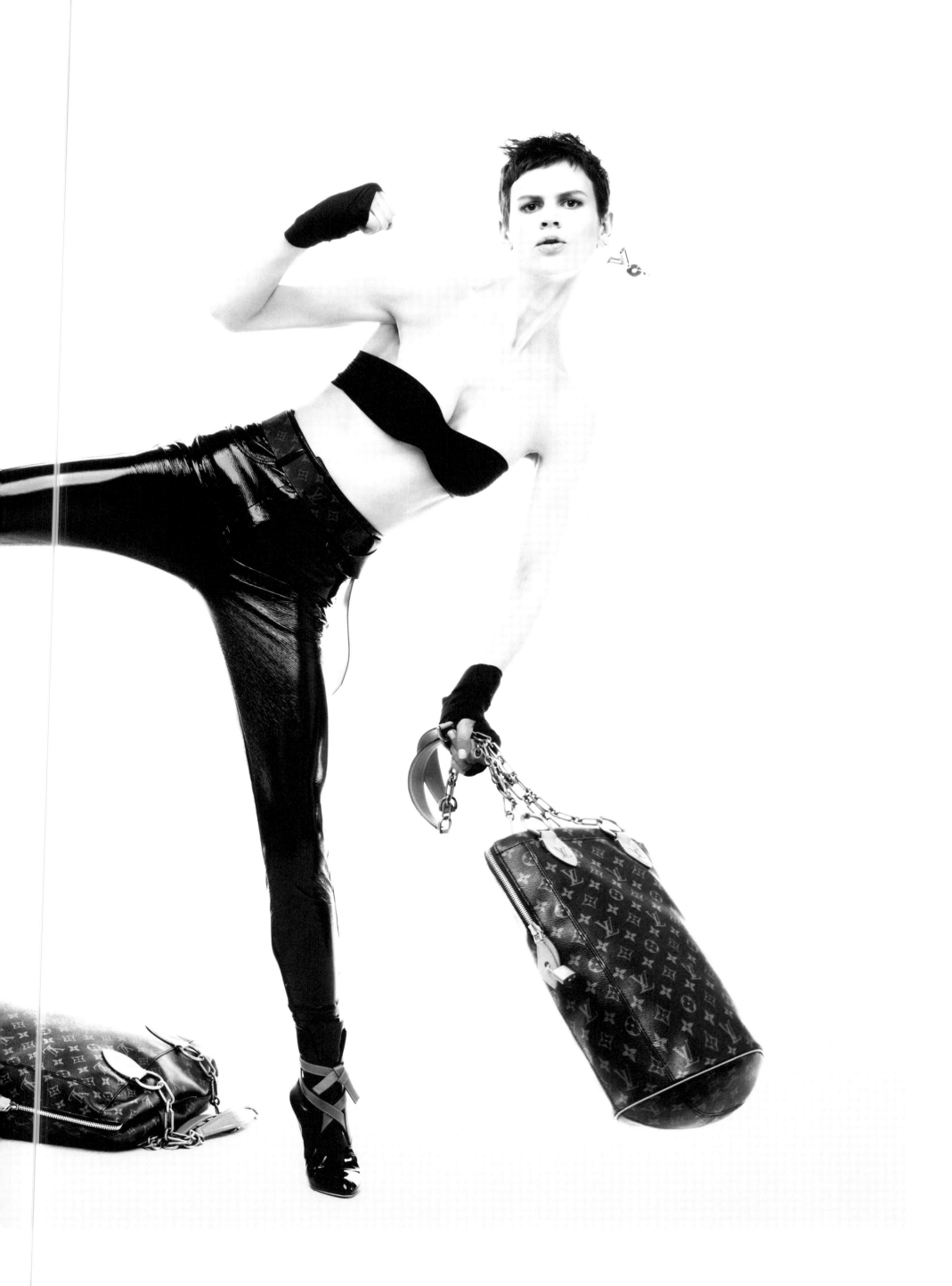

I am always with the line from Voltaire, that *"Everything that needs an explanation, isn't worth the explanation."* So what can I explain?

By now you've seen what I did? It is fun! In fact I had several ideas and LOUIS VUITTON wanted to do them all -- why not? In a way they are connected but all of the boxing things are related.

I know more and more women -- and men too -- who have started to box. I thought it was something that one should do, if possible, in a very expensive way. So I designed the huge piece of luggage with the punching bag in it. I also wanted to make a bag that was inspired by that idea; it comes in different sizes. We made a special carpet, with an application for beginners: where and how to put your feet and how to move. There is also a little bag with boxing gloves, it can be taken to the boxing appointment -- I wanted to have a special MONOGRAM for that too. It was really very childish, simple thinking!

I imagined people would keep the trunk in their dressing rooms and use it as a closet. You remove the punching bag, put that on its special metal stand, and use it like that. You can use the shelves, put them in the trunk and it becomes a very chic closet. There is a system that you put under it, to move it on wheels. And you can then push it into the house. It is a huge toy for spoiled, grown-up people!

I don't know how I had the idea. I had an electronic flash and saw it. You cannot really count on this kind of inspiration. For the moment it works! If you are not one hundred per cent on the roll it does not work. This job is full time, even if you do other things -- and I am not really a holiday person. You know I sketch everything myself? I have a studio where other people sketch too, but if it isn't done by me I am bored! For the LOUIS VUITTON project I sketched everything by hand. I know others do computer sketches, but I always have to use my hands. Sketching and writing for me are very physical things.

I was not tempted to make something for Choupette -- LOUIS VUITTON already have a carrier for cats. They made one for her already, that one is perfect. There are so many things going on for Choupette anyway! She has two books coming out, one soon and another at the end of the year, she has her make-up line.

KARL LAGERFELD

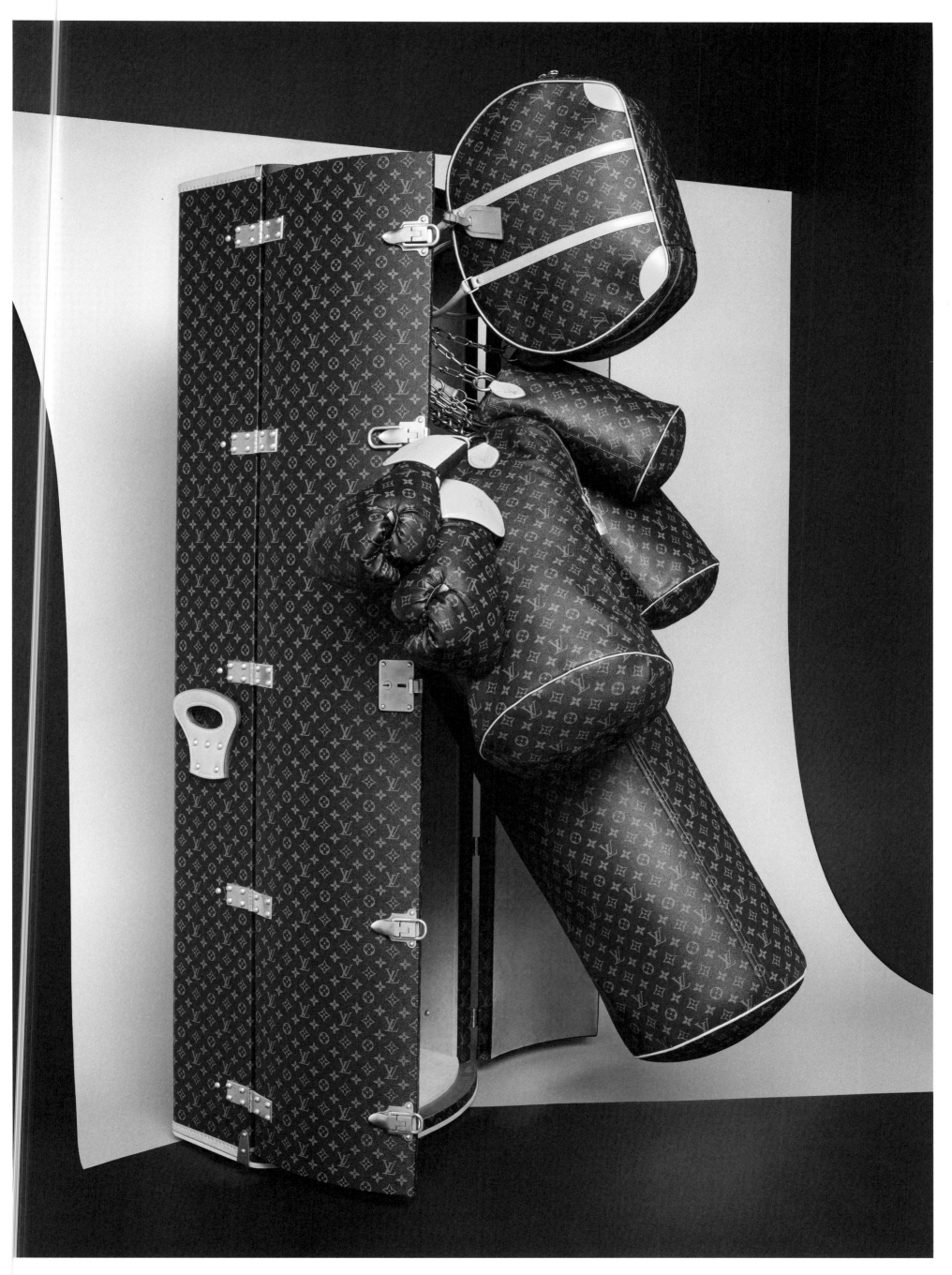

Karl Lagerfeld trunk, punching bags, boxing gloves and suitcase photographed by Erwan Frotin

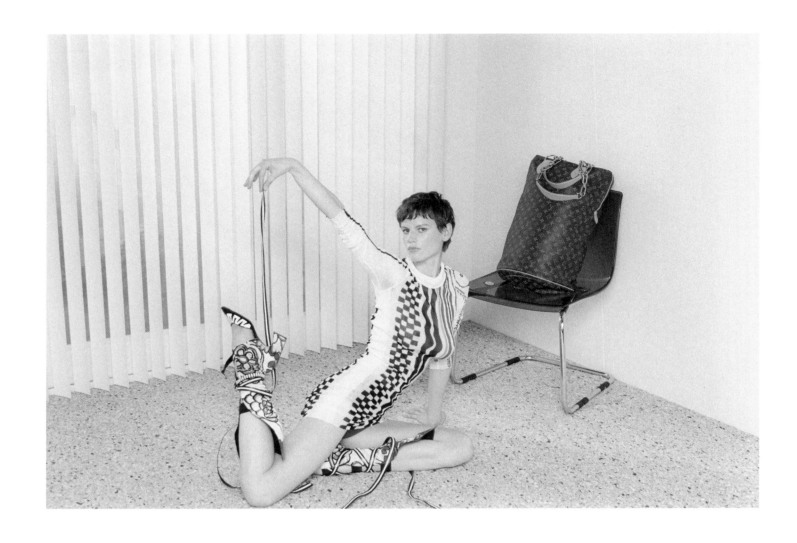

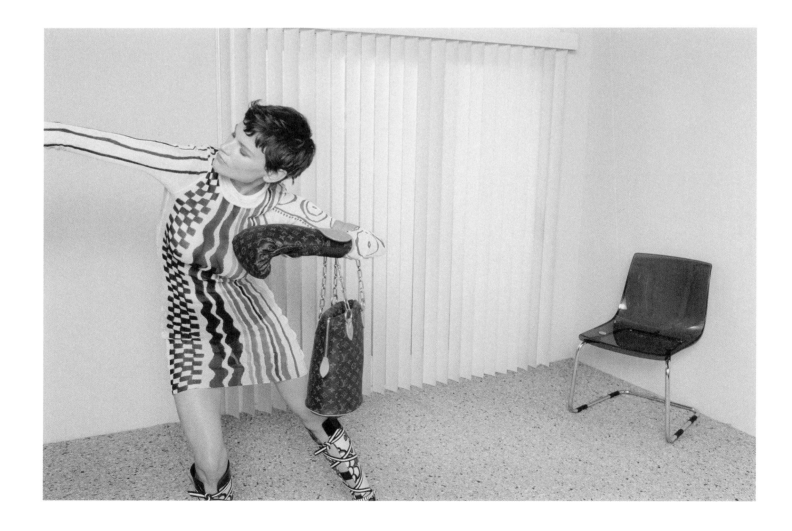

Saskia de Brauw photographed by Colin Dodgson

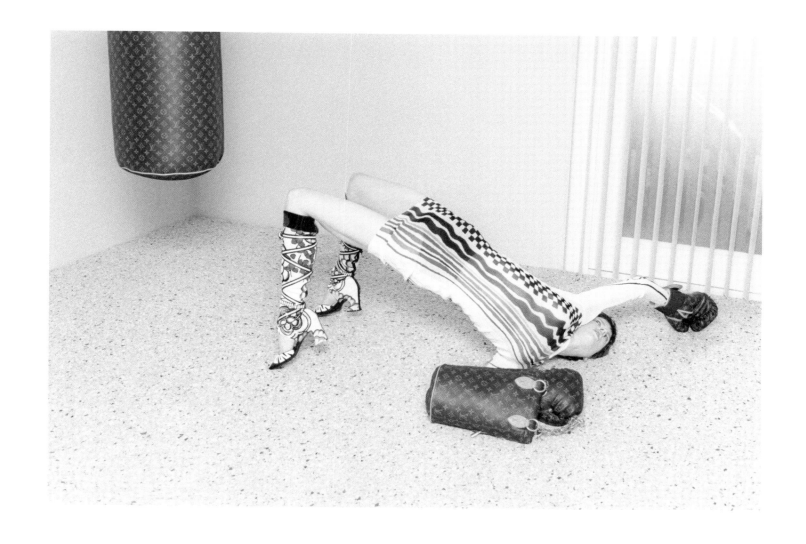
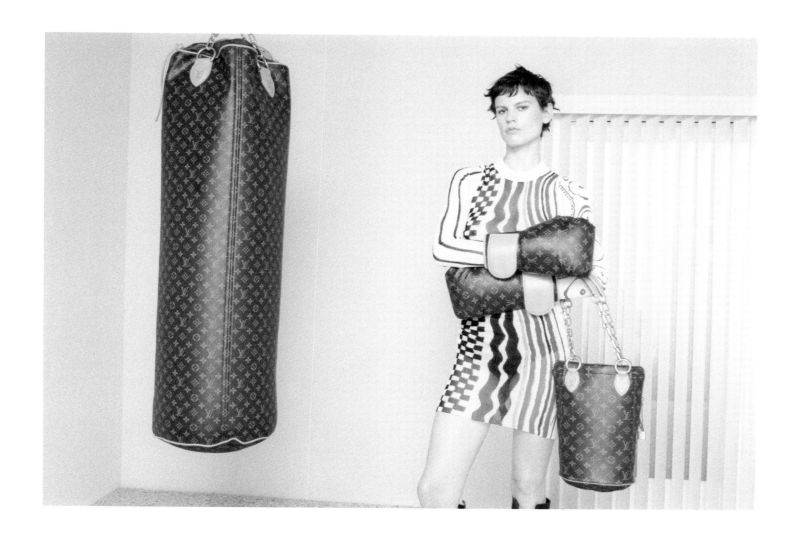

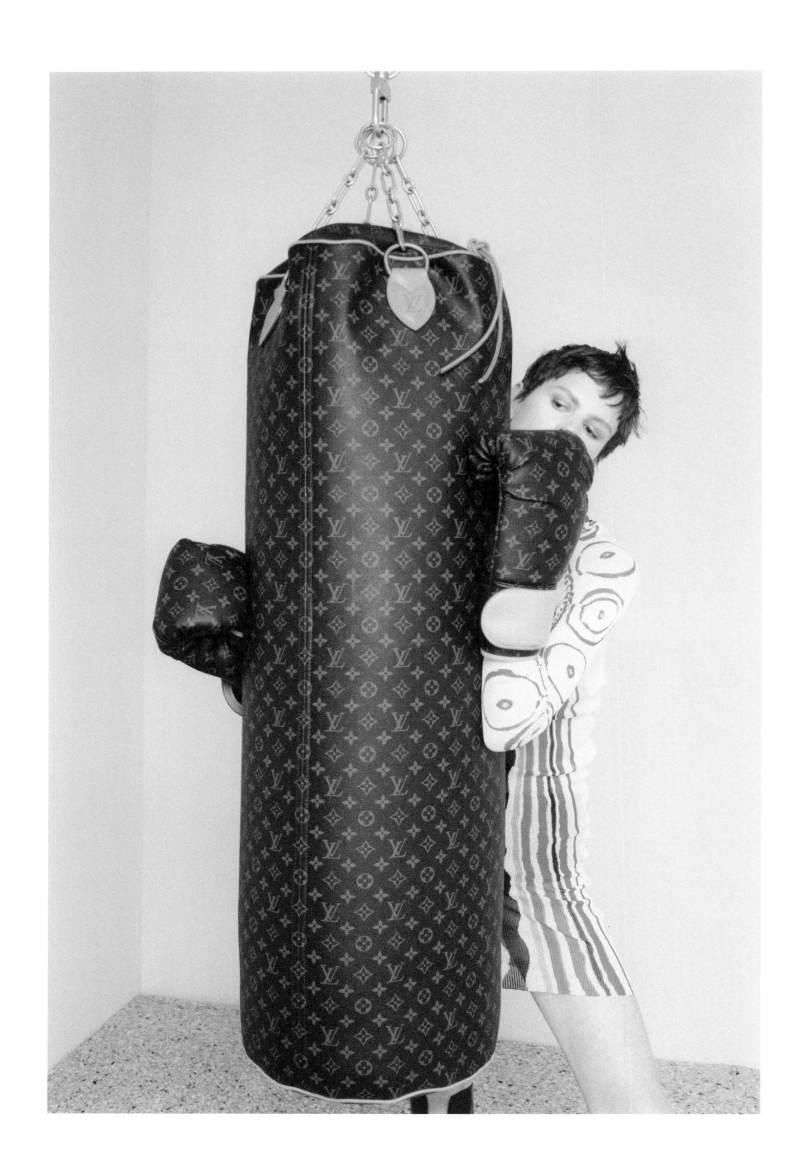

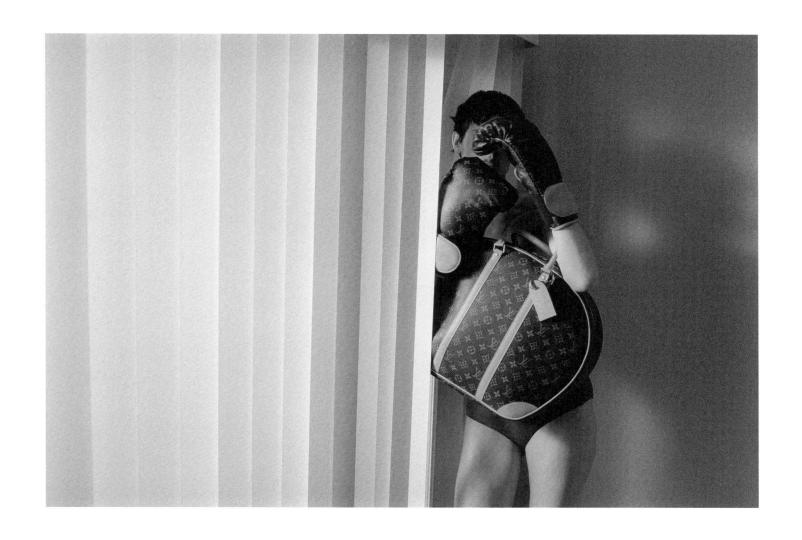

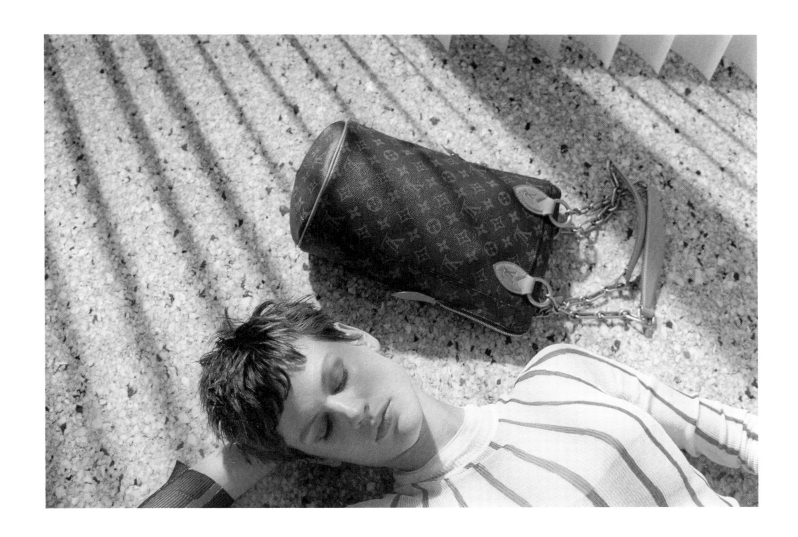

M.N

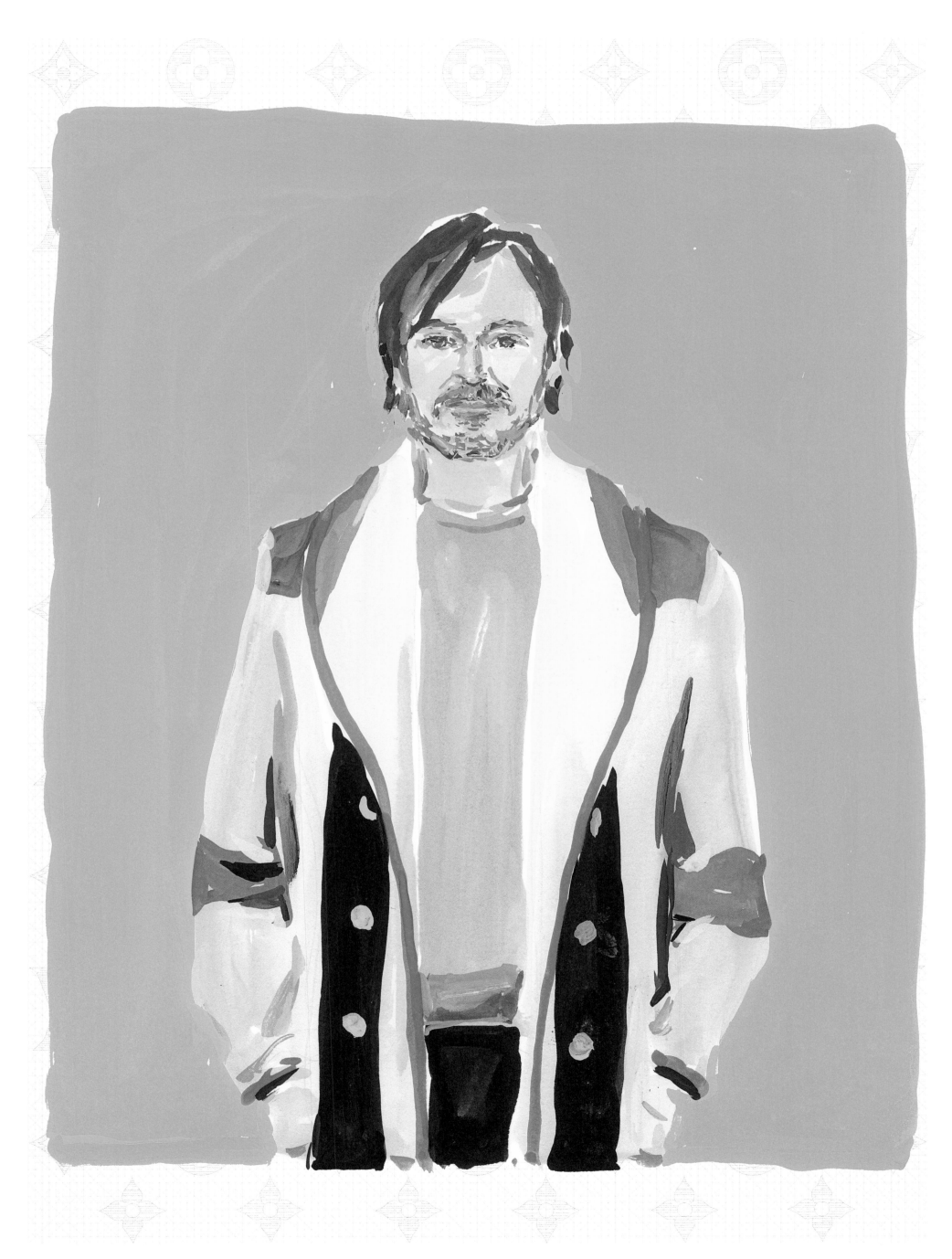

Marc Newson by Jean-Philippe Delhomme

MARC
NEWSON

Initially studying sculpture and jewellery design
before teaching himself in industrial design,
MARC NEWSON's route might be seen to have
contributed to his iconoclastic approach and
the embracing of a distinctly personal design
signature. Now, widely acknowledged as the most
influential industrial designer of his generation,
MARC NEWSON has worked in numerous industries
ranging from aerospace and technology to furniture
and fashion.

Instinctively and personally driven in
his approach, iconoclastically collapsing
the boundaries between disciplines and
idiosyncratically embracing a wide range of
design work as a totality, MARC NEWSON could be
seen as a unique figure in his field.

His *Lockheed Lounge* piece, initially made when
the designer was only 23 years old and had just
graduated, has gone on to become one of the true
design icons of our era.

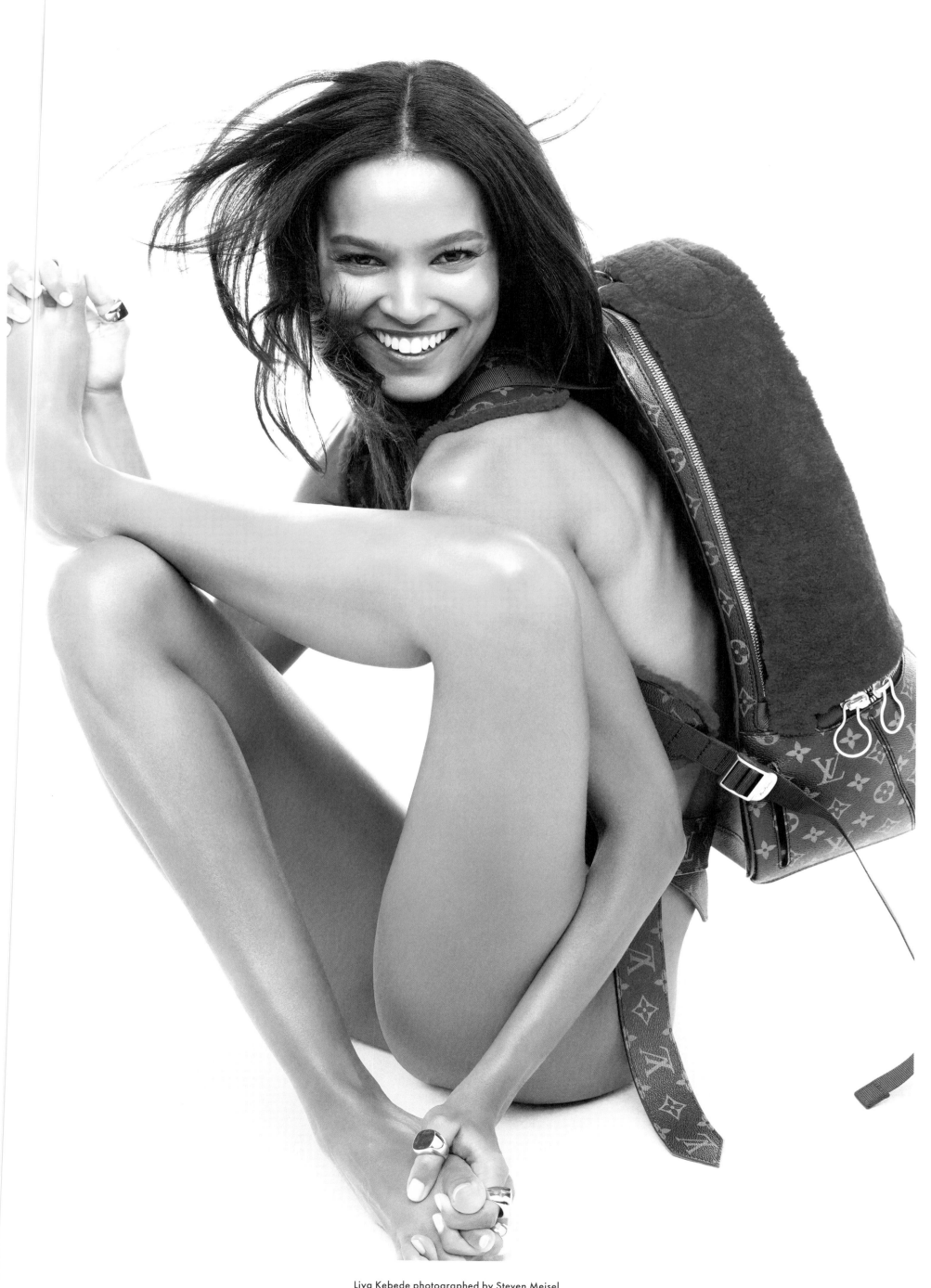

Liya Kebede photographed by Steven Meisel

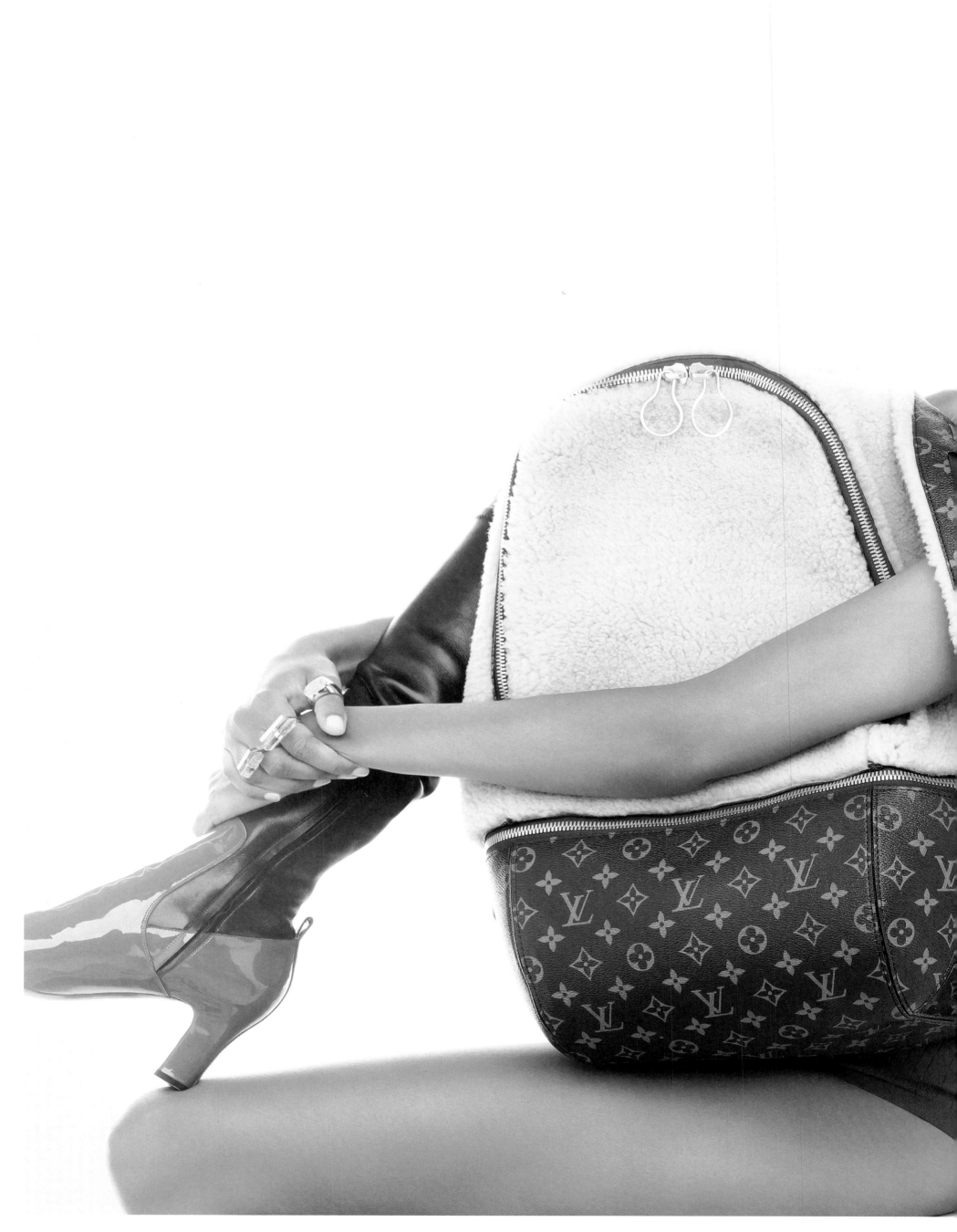

Liya Kebede and Freja Beha Erichsen photographed by Steven Meisel

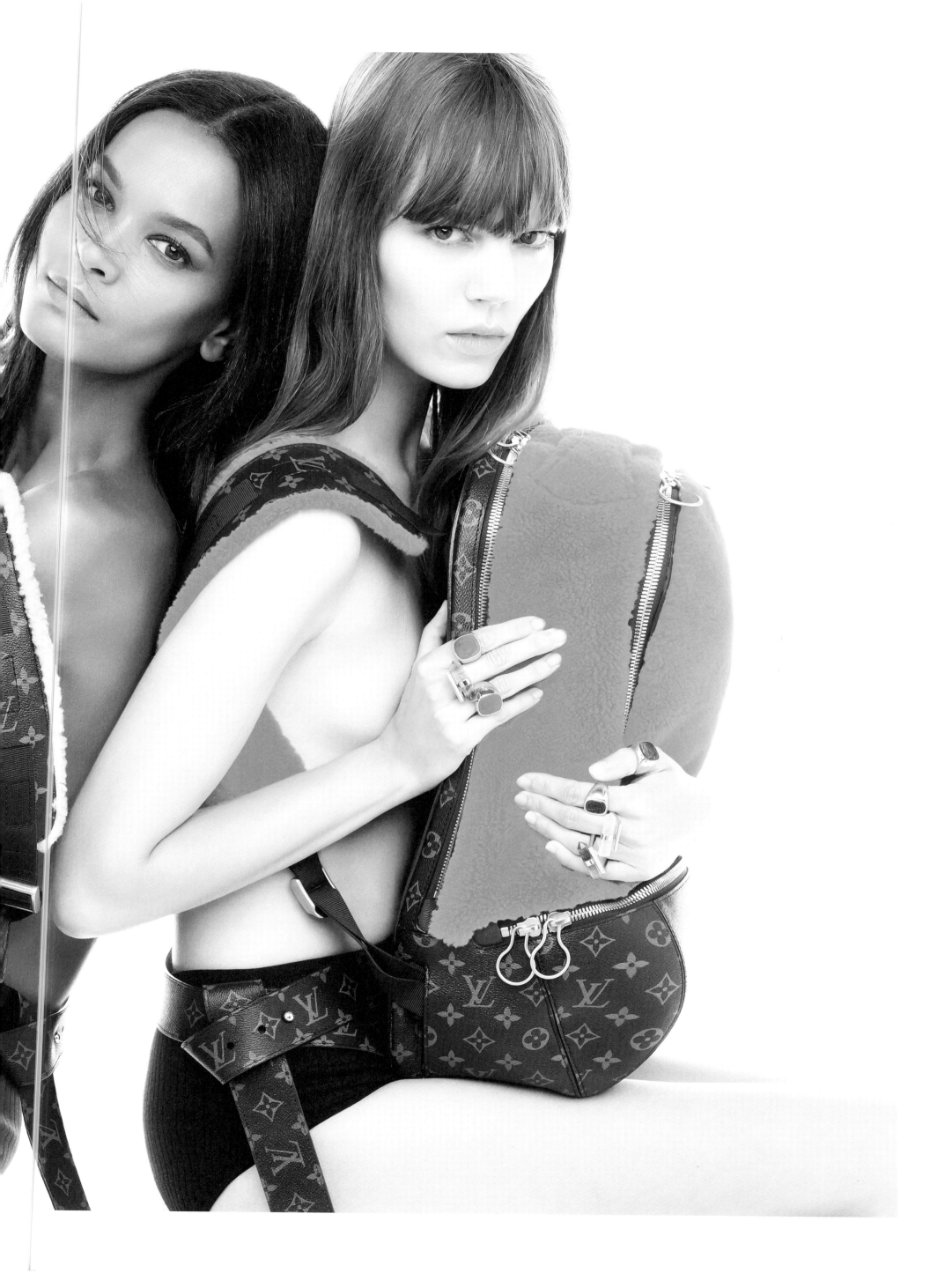

I design things that I fundamentally would like to own. I figured there must be other people out there who would be the same as me.

One of the lovely things about this project is that LOUIS VUITTON gave me a completely open brief. Most of the time I am presented with a very defined task. This time I ultimately thought of the typology myself: a backpack. It was a much easier place for me to start than say thinking about a handbag, as I am much more likely to use a backpack!

I wanted the bag to work; I didn't want it to weigh a ton, and above all, I wanted to use it. I didn't want to design a piece that was going to be a "wall hanging." I wanted other people to see it and want to use it too, not just respond to the immediate attraction of it on a shelf. I set about trying to collate all of my experiences over the years of owning a backpack. I wanted to concentrate all of the features that I love and try and put them into the piece. Making the thing stand up for example, was important I hate when you wear a backpack, take it off and it just falls over when you put it on the ground. This bag has a structure inside to enable it to stand.

I wanted to explore MONOGRAM functional qualities. If you go back to the reason why the MONOGRAM canvas was invented, it is because it is durable and weather proof — it is designed for abuse! In the bag it performs a very specific function; I deliberately used it around the base so it almost became like a tyre on a car, or a sole on a shoe. Obviously you still see it, but it has a purpose.

I wanted it to be fun as well — I don't like when things take themselves too seriously. I used a textile that juxtaposed the utility of the MONOGRAM with something more light-hearted, that's why I chose to use the furry sheepskin. It just felt like the antithesis of the MONOGRAM in some ways: it is cuddly and warm and in bright colors. But it is also durable and like a pillow; if I ever want to prop the bag up and have a snooze, I can.

The MONOGRAM has been downplayed in a sense and not treated in such a reverential way in the bag — but that was part of the fun of it. I want objects that put a smile on people's faces, make them laugh and question their own seriousness.

MARC NEWSON

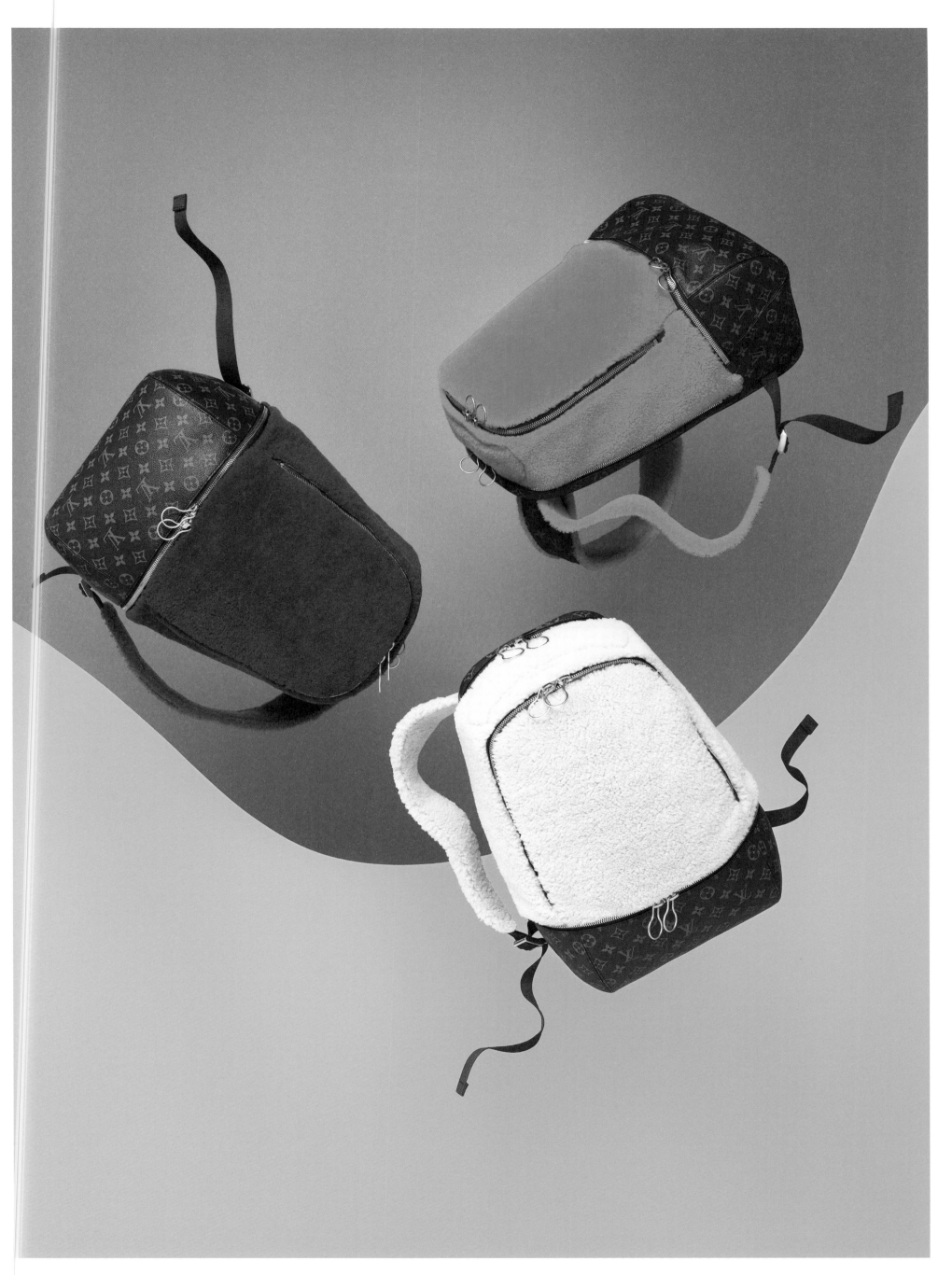

Marc Newson backpacks photographed by Erwan Frotin

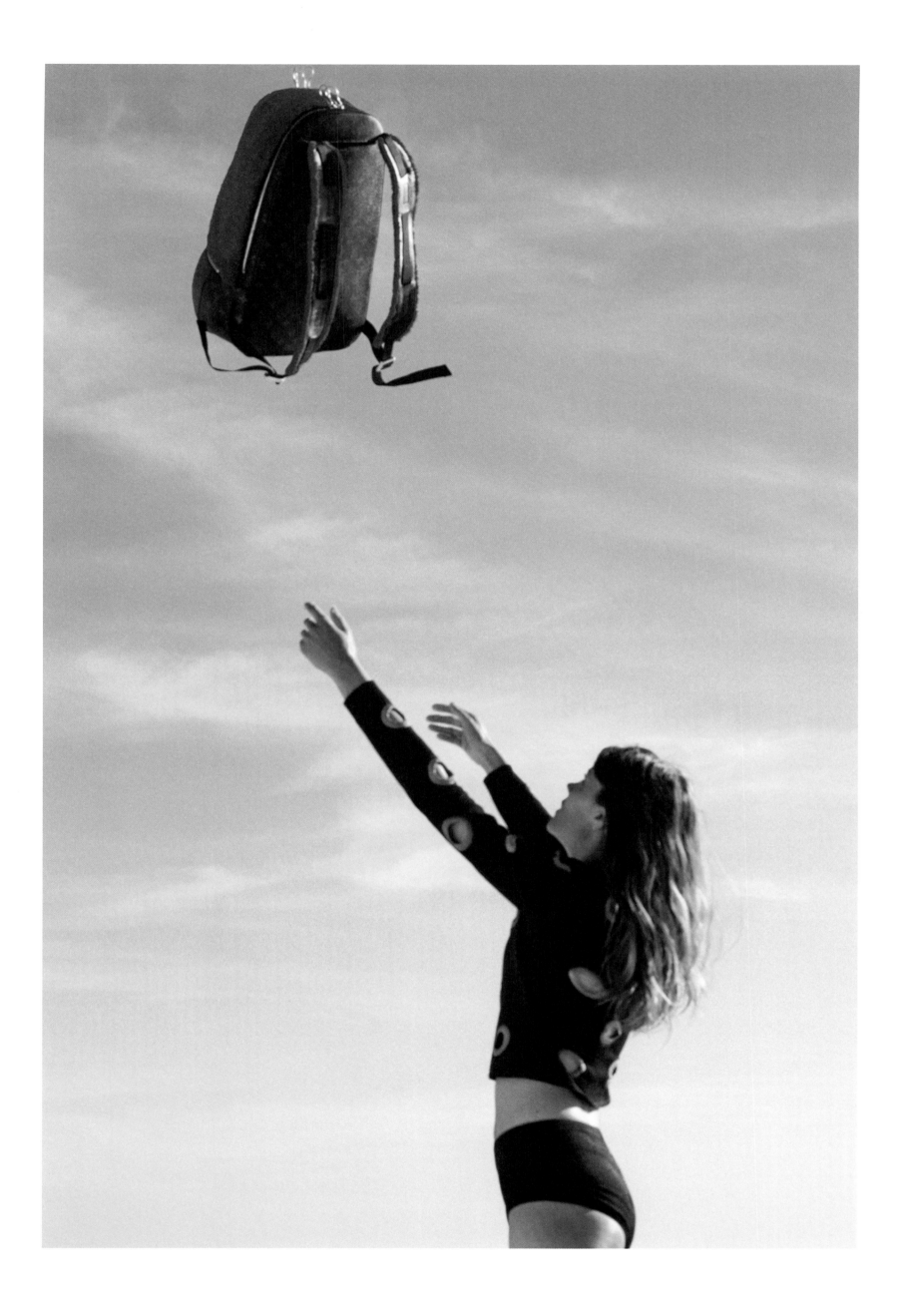

Freja Beha Erichsen and Liya Kebede photographed by Michael Avedon

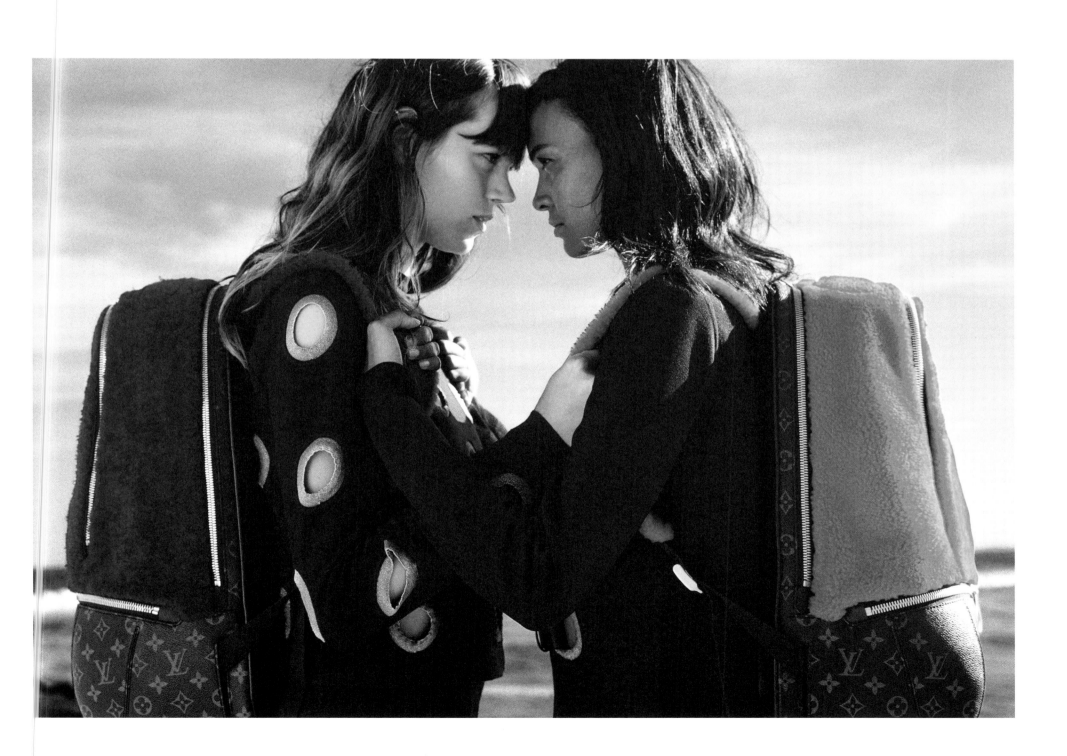

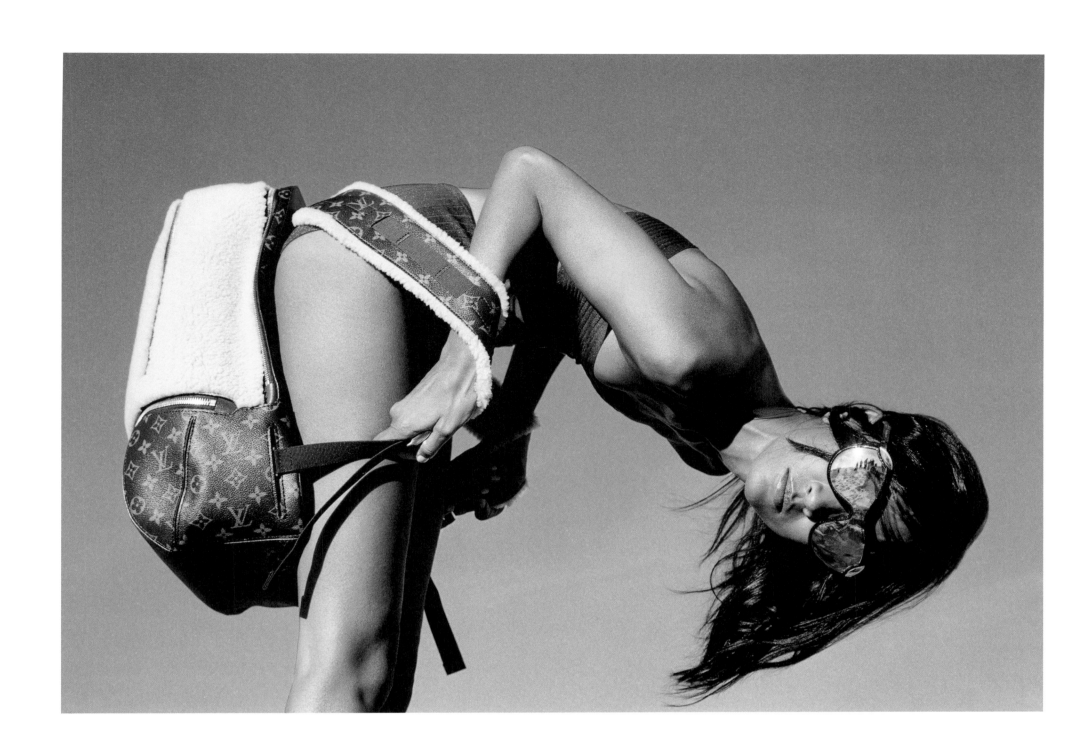

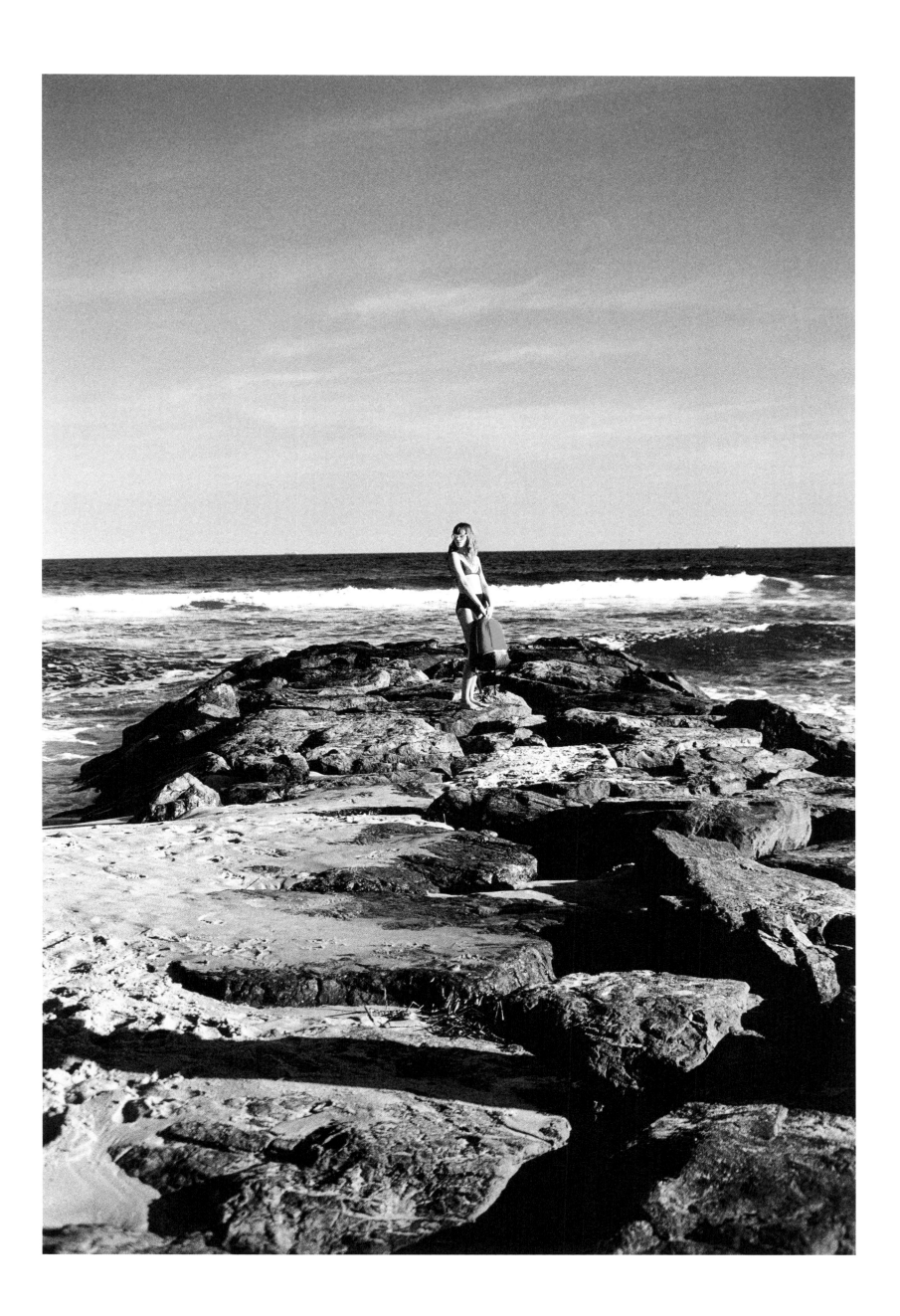

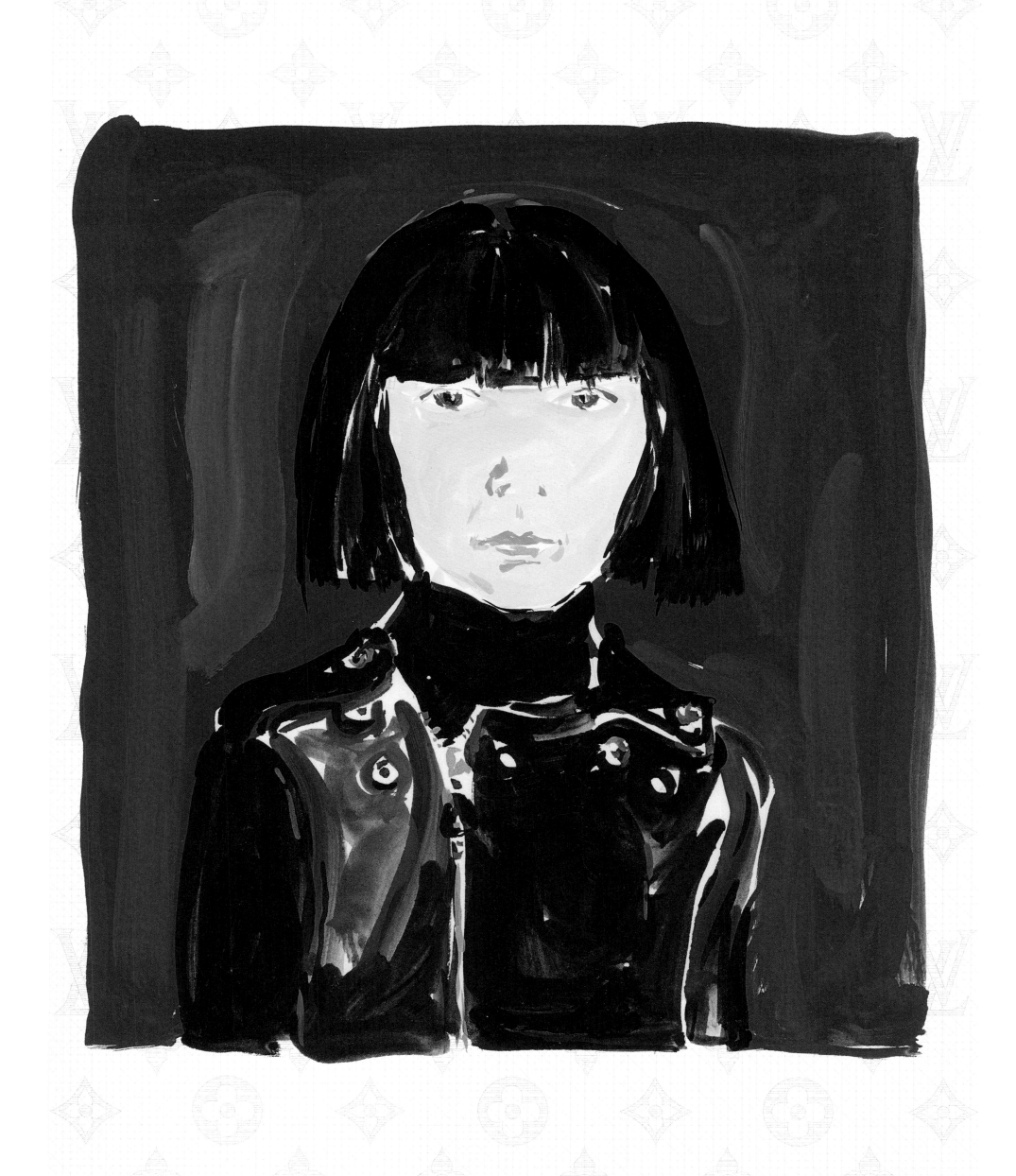

Rei Kawakubo by Jean-Philippe Delhomme

REI
KAWAKUBO

After studying art and literature, REI KAWAKUBO
quickly changed tack, working for a textile
company and then becoming a self-taught
fashion designer.

Believing that there are no limits to creativity
in the fashion process, she has constantly
radically pursued and iconoclastically achieved
perpetual progress in her field, breaking the
rules and making new ones that the entire industry
has paid attention to.

These features have become the hallmarks of
Comme des Garçons, the label that REI KAWAKUBO
founded in 1969 and incorporated as a company in
1973. REI KAWAKUBO has an input into all areas of
the creative process, from graphics, advertising
and store interiors to designing and making
clothes and accessories; each is inextricably
linked. In 1981 she staged her first, and now
legendary, Paris show for Comme des Garçons.

After an initial outcry, her iconoclastic
aesthetic and her love of black changed the wider
global -- and more commonly perceived -- notion
of beauty in fashion forever. REI KAWAKUBO called
her label Comme des Garçons -- "Like the Boys" --
just because she liked the sound of it.

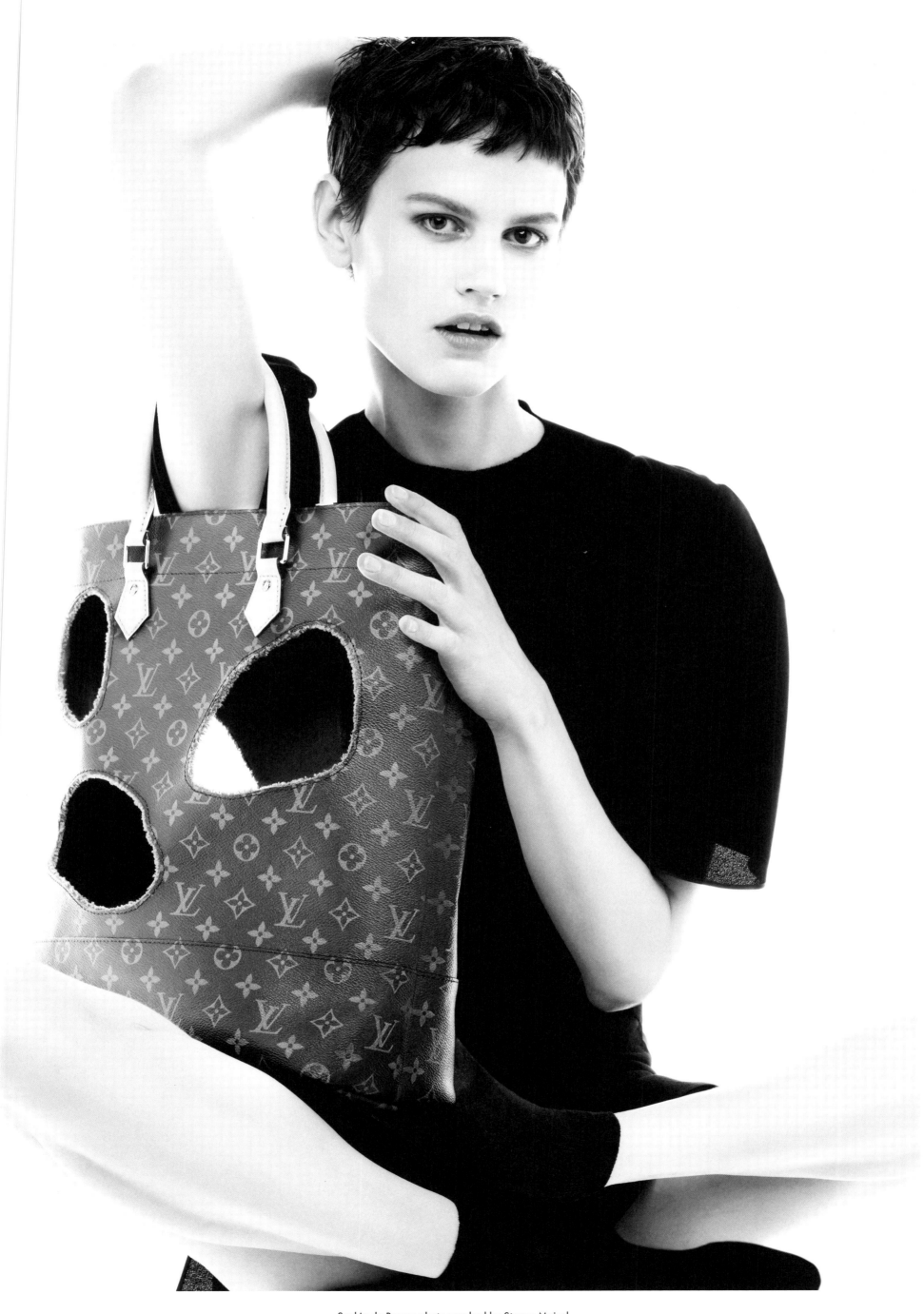

Saskia de Brauw photographed by Steven Meisel

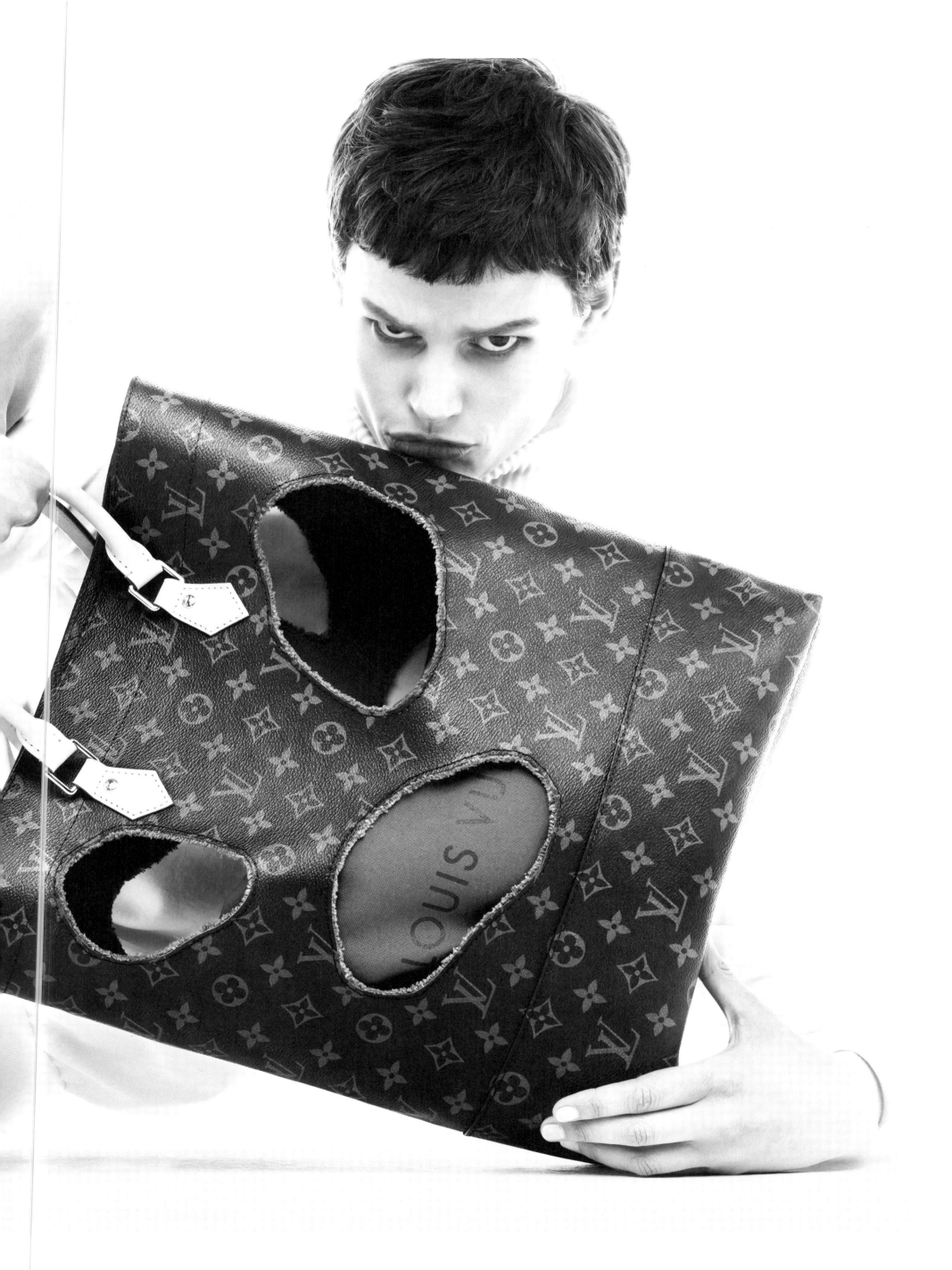

Breaking the traditional LOUIS VUITTON MONOGRAM
was the premise of this work -- to find something
that would be new, some kind of new value.

 Although there are various ways of breaking to create
something new, this time I tried to play it straight:
I simply made some holes in the fabric of the bag.
I generally like small bags.

 I feel that LOUIS VUITTON is the house that most
beautifully and skilfully transforms what is tradition
into what is now.

 Yet I always approach all of my work in a way that is
exactly the same: I look to create something new.

 When designing the bag for this project, I was looking
for some new design, something that hadn't been done
before, something within the limits of possibility.

 REI KAWAKUBO

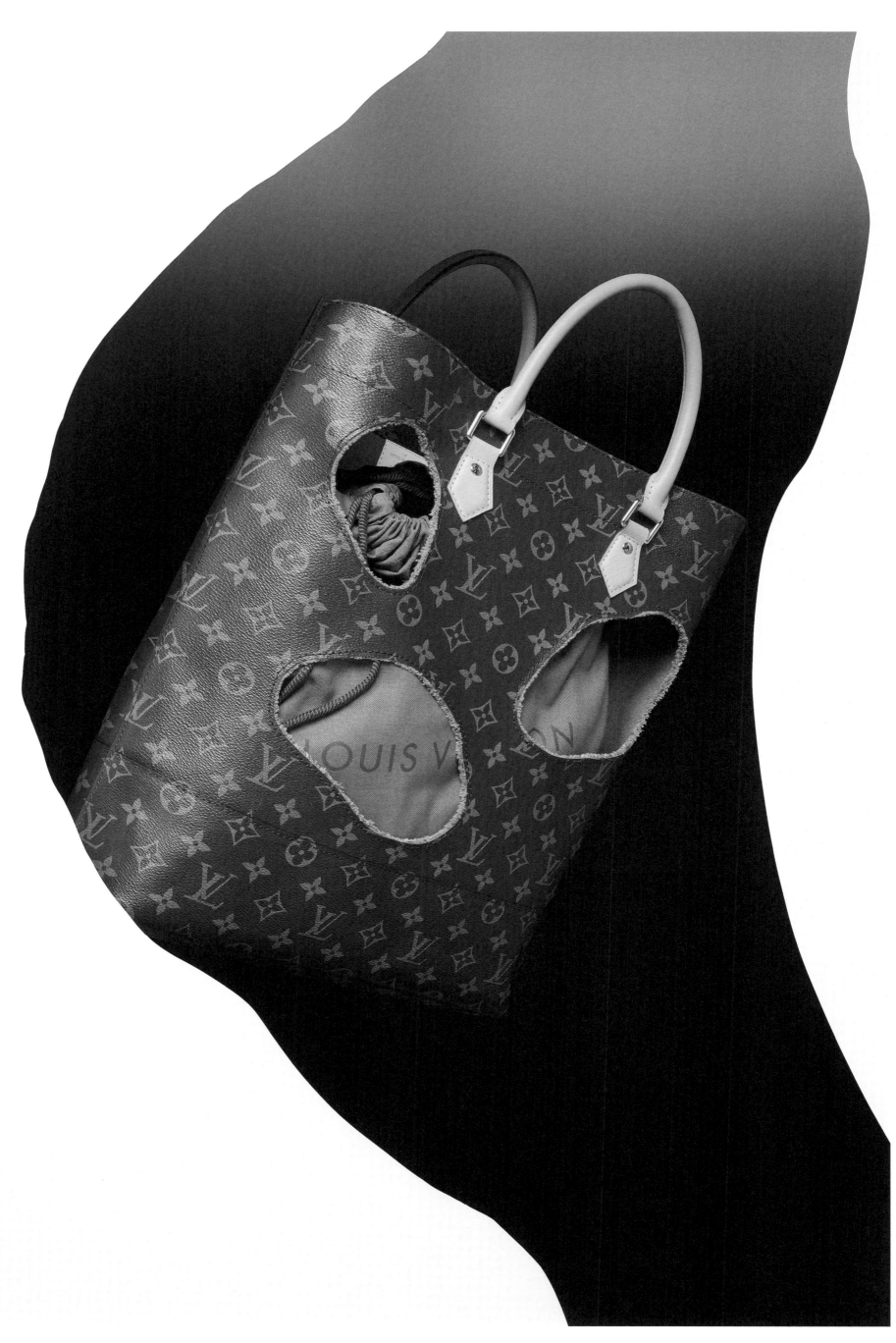

Rei Kawakubo bag photographed by Erwan Frotin

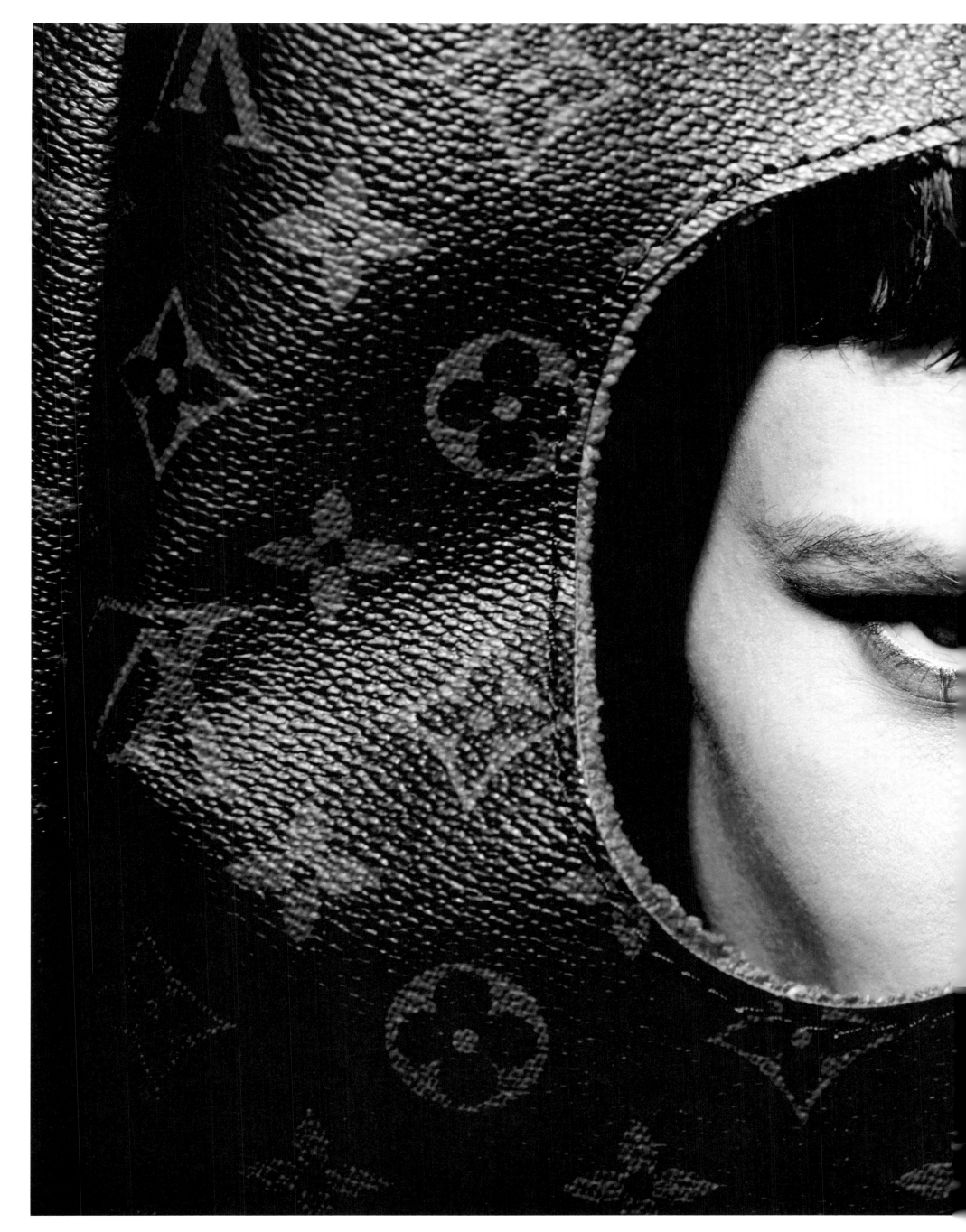

Saskia de Brauw photographed by Jennifer Livingston

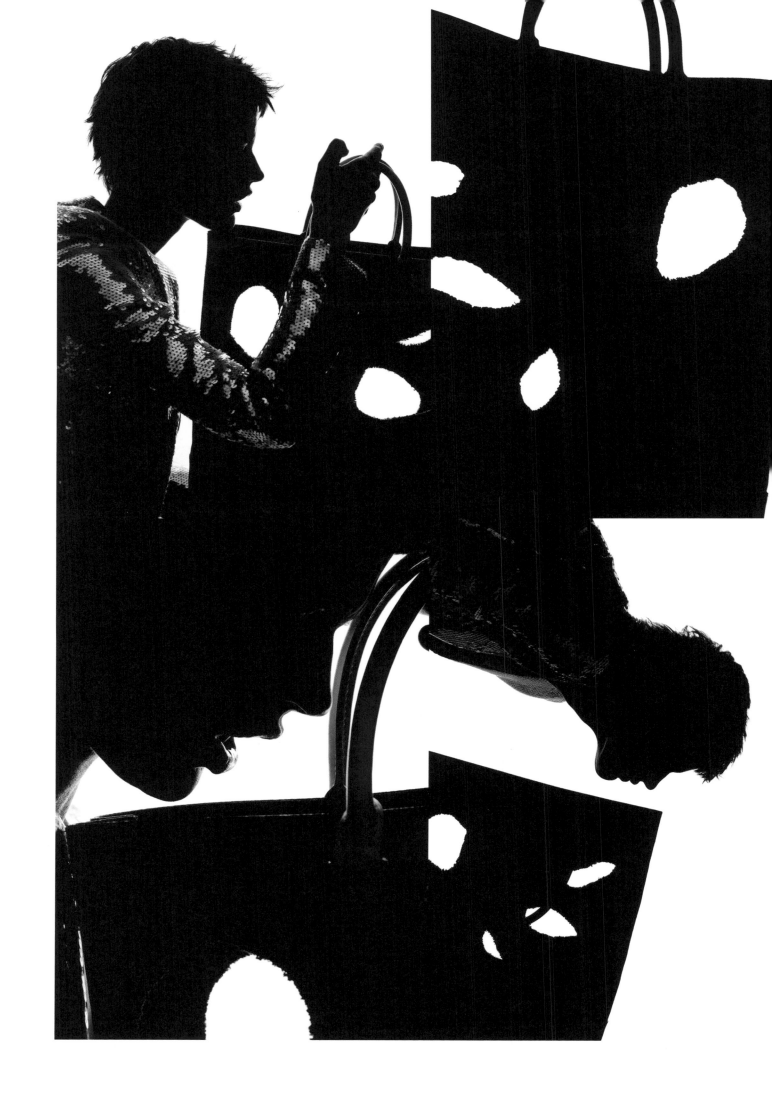

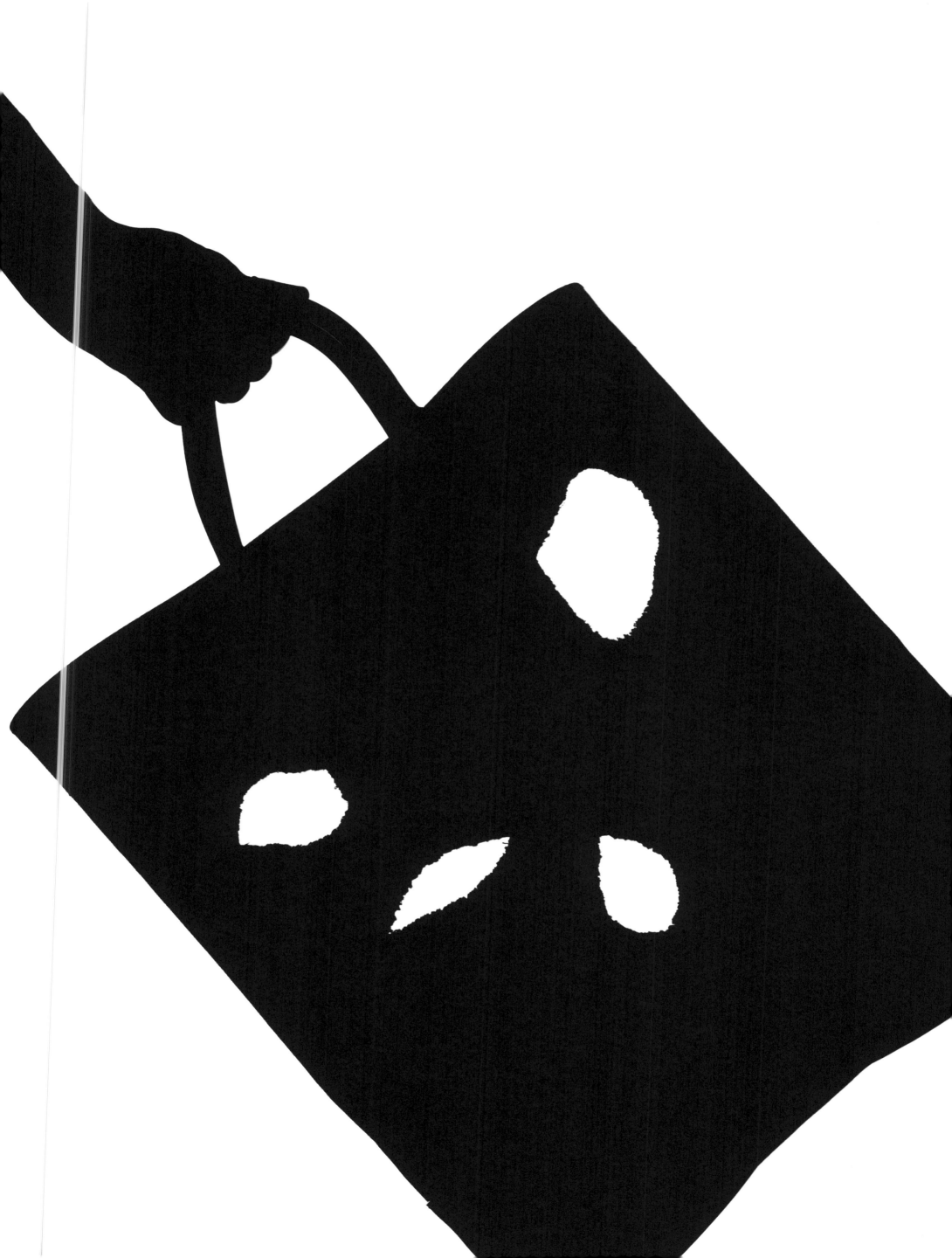

© Louis Vuitton/Jo-Ann Furniss, 2014:
p. 5-7, 15, 20, 29, 34, 43,
48, 57, 62, 71, 76, 85, 90

© Archives Louis Vuitton:
p. 4, 7

© Louis Vuitton/Michael Avedon,
creative direction by Robert Lussier & Mia Forsgren,
styled by Carine Roitfeld,
featuring Freja Beha Erichsen and Liya Kebede; 2014:
p. 78-81

© Louis Vuitton/Pierre Debusschere,
creative direction by Robert Lussier & Mia Forsgren,
styled by Carine Roitfeld,
featuring Julia Nobis; 2014:
p. 50-53

© Louis Vuitton/Jean-Philippe Delhomme,
creative direction by M/M (Paris); 2014:
p. 8-9, 14, 28, 42, 56, 70, 84

© Louis Vuitton/Colin Dodgson,
creative direction by Robert Lussier & Mia Forsgren,
styled by Carine Roitfeld,
featuring Saskia de Brauw; 2014:
p. 64-67

© Louis Vuitton/Johnny Dufort,
creative direction by Robert Lussier & Mia Forsgren,
styled by Carine Roitfeld,
featuring Julia Nobis; 2014:
p. 36-39

© Louis Vuitton/Erwan Frotin,
creative direction by M/M (Paris); 2014:
p. 10-11, 21, 35, 49, 63, 77, 91

© Louis Vuitton/Jennifer Livingston,
creative direction by Robert Lussier & Mia Forsgren,
styled by Carine Roitfeld,
featuring Saskia de Brauw; 2014:
p. 92-95

© Louis Vuitton/Steven Meisel,
creative direction by Robert Lussier & Mia Forsgren,
styled by Carine Roitfeld; 2014:
p. 17 (featuring Freja Beha Erichsen),
18 (featuring Julia Nobis),
31-32 (featuring Julia Nobis),
45-47 (featuring Julia Nobis),
59-61 (featuring Saskia de Brauw),
73 (featuring Liya Kebede),
74-75 (featuring Liya Kebede and Freja Beha Erichsen),
87-89 (featuring Saskia de Brauw)

© Louis Vuitton/Gordon von Steiner,
creative direction by Robert Lussier & Mia Forsgren,
styled by Carine Roitfeld,
featuring Saskia de Brauw; 2014:
p. 22-25

THE ICON
and THE ICONOCLASTS

Celebrating Monogram

Edited and designed
at M/M (Paris)

Texts by
Jo-Ann Furniss

Cover:
Blueprint Monogram
and Iconoclasts Initials
by M/M (Paris)

First Edition
Published in 2014

© 2014, Rizzoli International Publications

First published in the United States of America
by Rizzoli International Publications, Inc.
300 Park Avenue South, New York, NY 10010

www.rizzoliusa.com

Printed in Italy
by Graphicom S.r.l.

ISBN 978-0-8478-4560-6
2014 2015 2016 2017 2018/10 9 8 7 6 5 4 3 2 1
Library of Congress Control Number:
2014947638